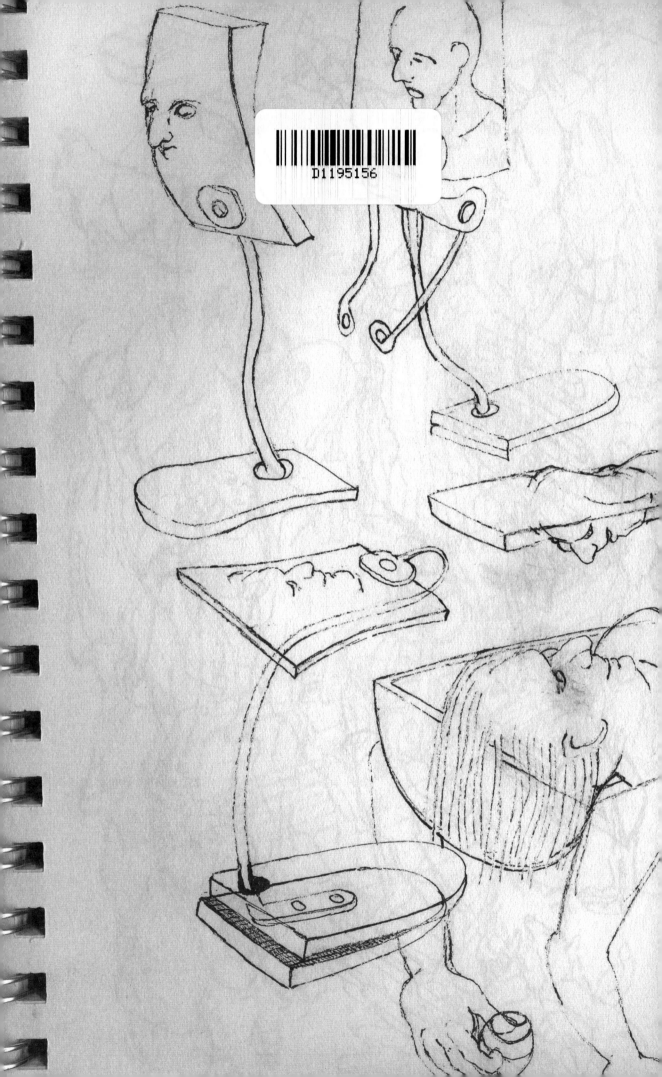

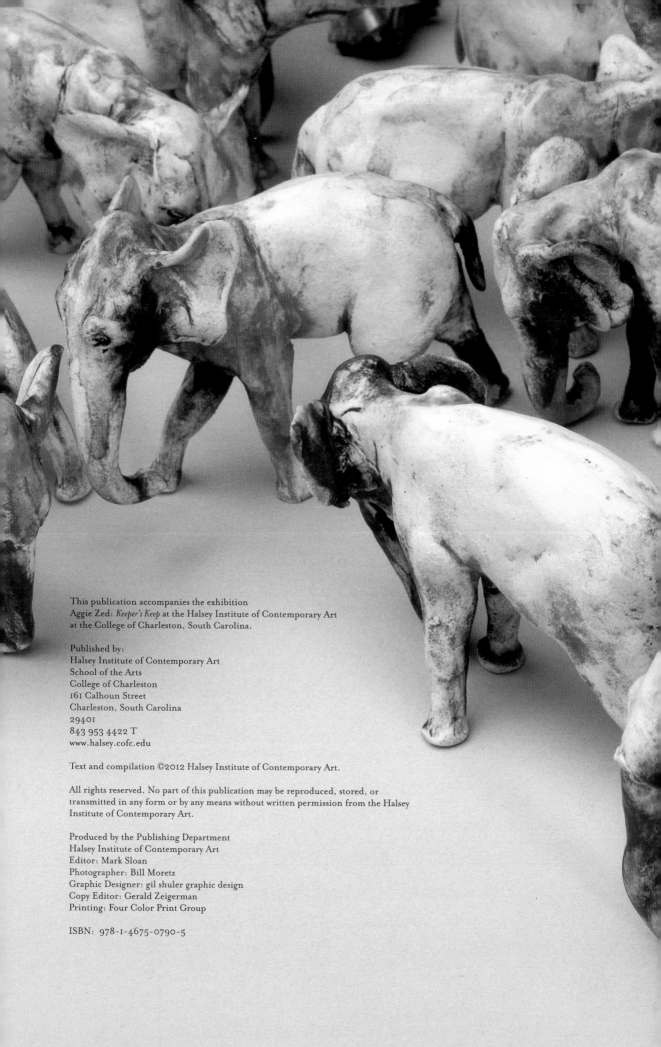

This publication accompanies the exhibition
Aggie Zed: *Keeper's Keep* at the Halsey Institute of Contemporary Art
at the College of Charleston, South Carolina.

Published by:
Halsey Institute of Contemporary Art
School of the Arts
College of Charleston
161 Calhoun Street
Charleston, South Carolina
29401
843 953 4422 T
www.halsey.cofc.edu

Produced by the Publishing Department
Halsey Institute of Contemporary Art
Editor: Mark Sloan
Photographer: Bill Moretz
Graphic Designer: gil shuler graphic design
Copy Editor: Gerald Zeigerman
Printing: Four Color Print Group

ISBN: 978-1-4675-0790-5

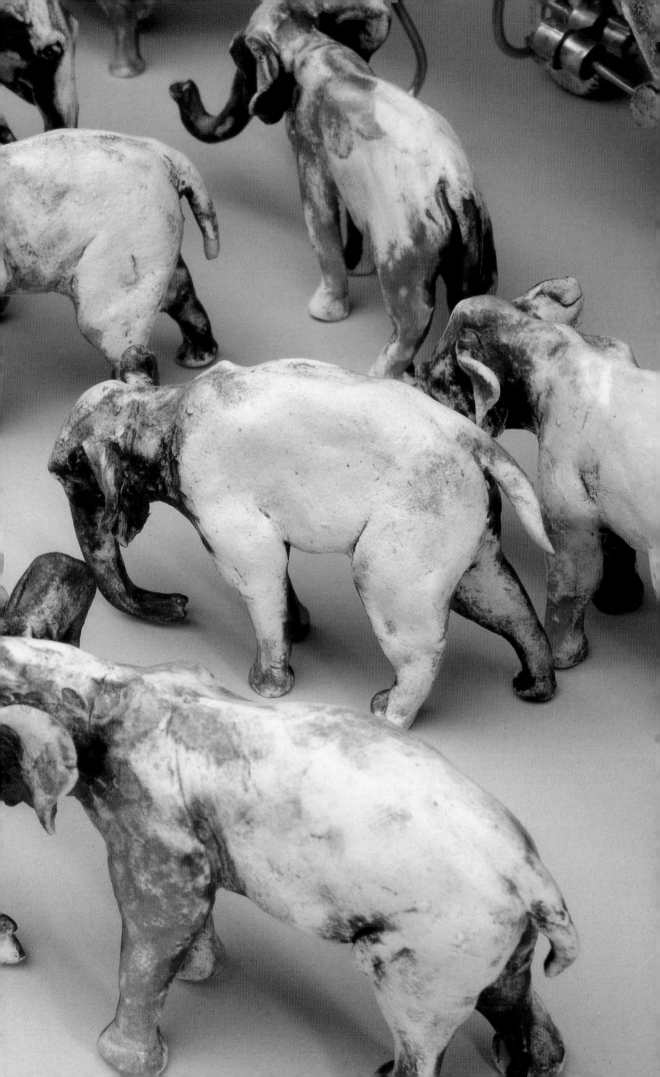

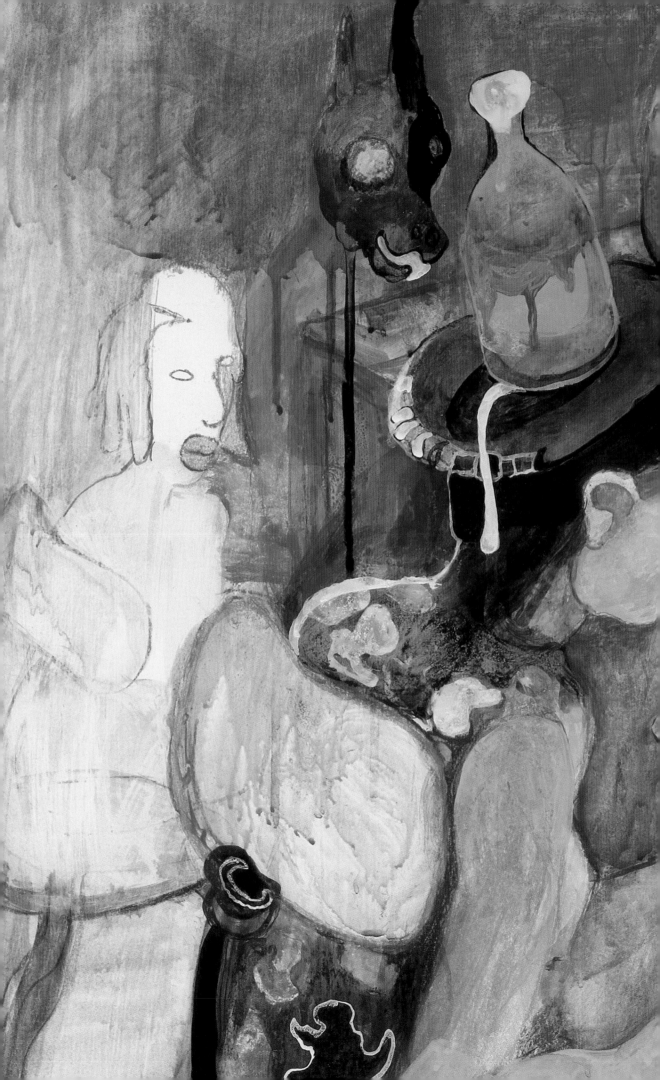

Aggie Zed

Keeper's Keep

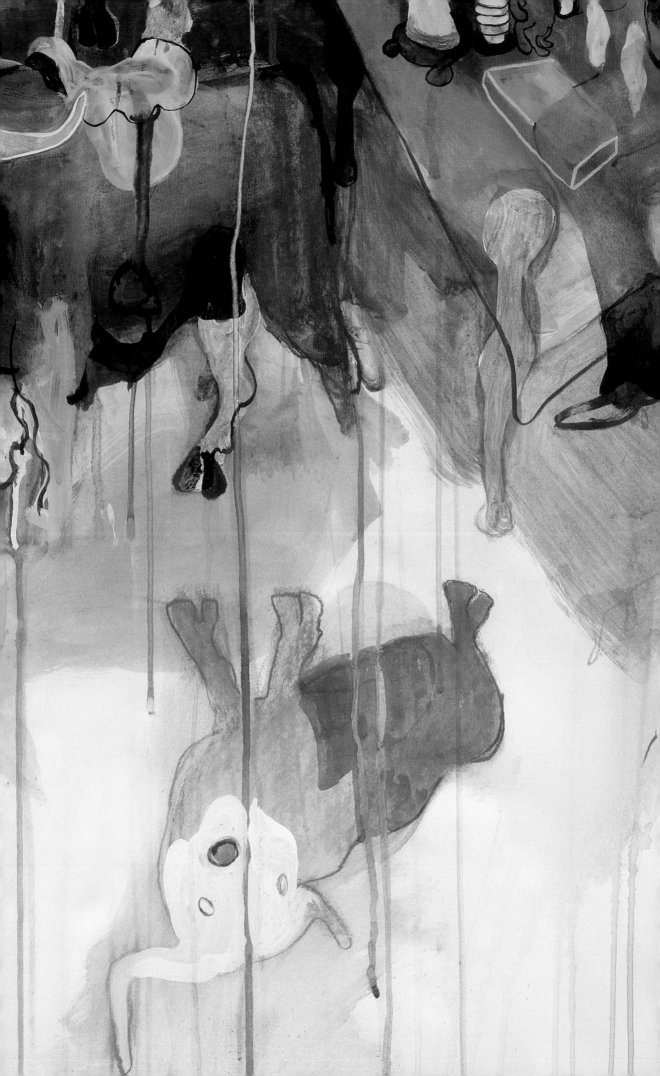

Contents

This exhibition is composed of sculpture, installations, paintings, drawings, and sketchbooks that chart Aggie Zed's unique working methods in a variety of media. Born in Charleston and raised among farm animals on Sullivan's Island, South Carolina, Zed graduated from the University of South Carolina with a BFA in painting and sculpture. Shortly thereafter, she moved to Richmond and, later, Gordonsville, Virginia, where she lives and works today.

Zed's studio practice is eclectic and varied. Often starting with images from her sketchbook, she may develop some of these concepts into paintings and others into sculptural tableaux or installations. Her subject matter is nothing less than the sum of human civilization, with an emphasis on our relationship to the animal kingdom. Human and animal figures collide with furniture or landscapes; rabbits sprout wheels or wings, while horses drown in collapsing scaffolding. Zed's dreamscape narratives probe the inner reaches of the subconscious mind.

Although Zed's work derives much of its meaning from literary associations, her imagery teems with invention and startling leaps of imagination. Her visual poetry conjures a world in which logic and rationality take a comfortable backseat. Human foibles and impulses are placed in the foreground. And even though she works in different media, her conceptual approach remains consistent throughout.

The paintings are rendered in mixed media on paper. They depict humans and/or animals, often located within a domestic space or farmyard. There may be references to dinosaurs seen from the windows or other anachronistic details. Mirrors, doorways, and framed artwork on the walls become portals to other realms. Animals play the role of participant observers to the human drama. They are depicted variously as companions, sages, sources of amusement, means of transportation, and foils to daily tasks.

The sculptural and installation works are complex tableaux that illuminate aspects of the human saga. Sculptural works that the artist calls "scrap floats" appear as if in some sort of cosmic procession, enacting scenes that are at once strange yet familiar. The collision of disparate materials and elements in these works mirrors the beauty and fragility of the human condition.

Derived from the title of one of the artist's works, *Keeper's Keep* alludes to British usage of the term "keeper" for "curator," and plays on the double meaning of "keep" as both noun and verb. Aggie Zed is a storyteller whose works take us out of our consensual reality and into a world filled with absurdity, ambiguity, and the gifts of artistic imagination.

Mark Sloan
Keeper

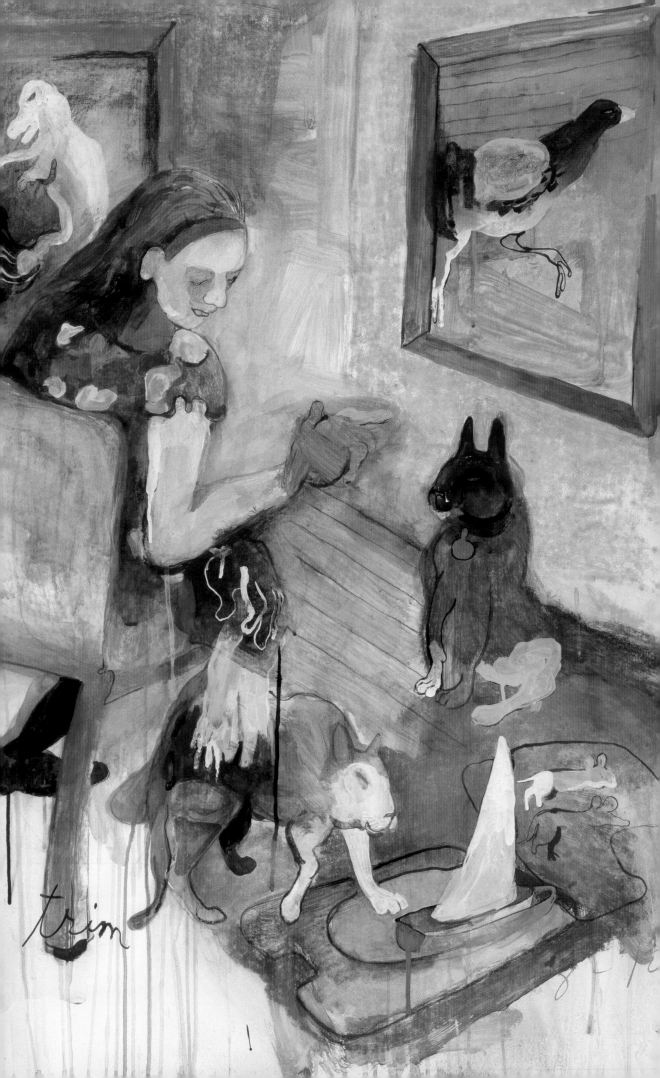

trim
2010
pastel, ink, acrylic on paper
40" x 26"

a toy kind
2011
pastel, ink, acrylic on paper
40" x 26"

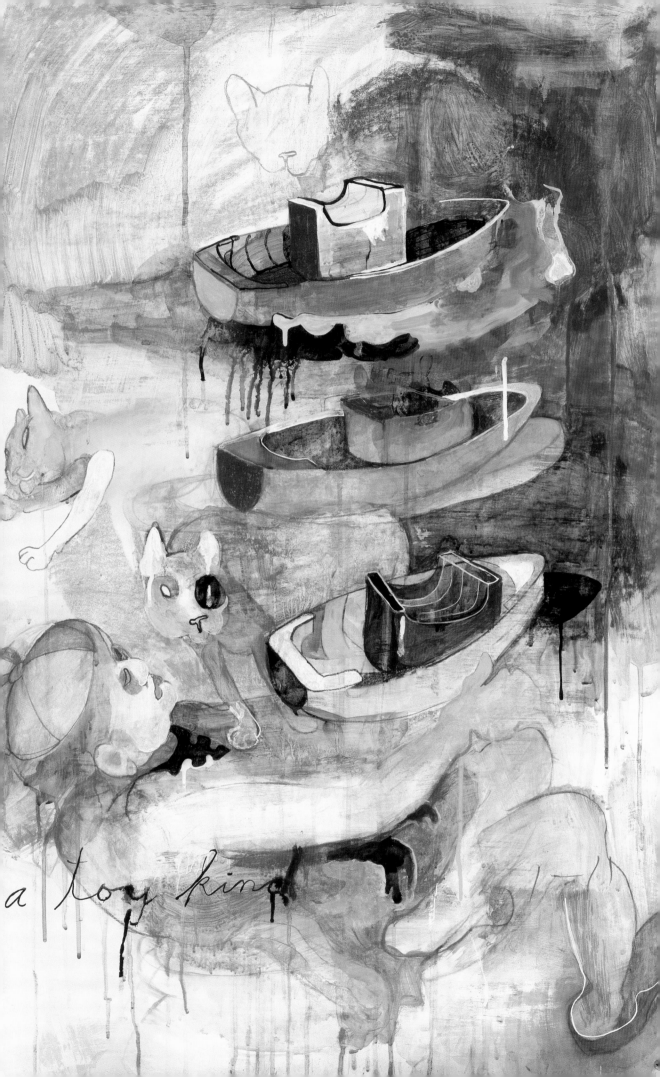

a toy king

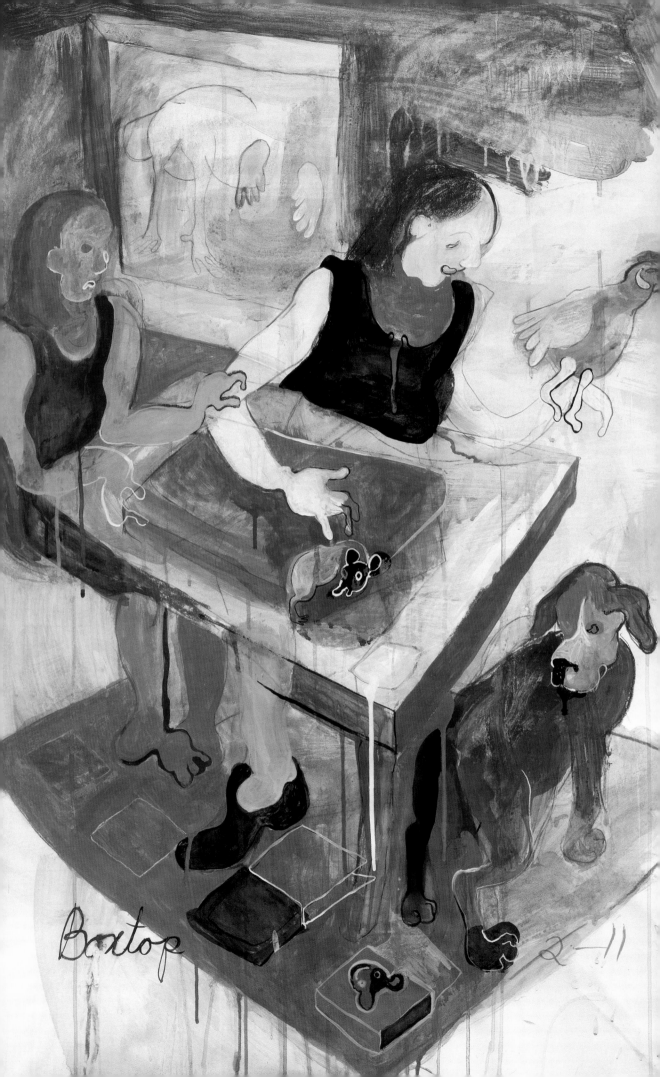

Boxtop
2011
pastel, ink, acrylic on paper
40" x 26"

geography
2011
pastel, ink, acrylic on paper
40" x 26"

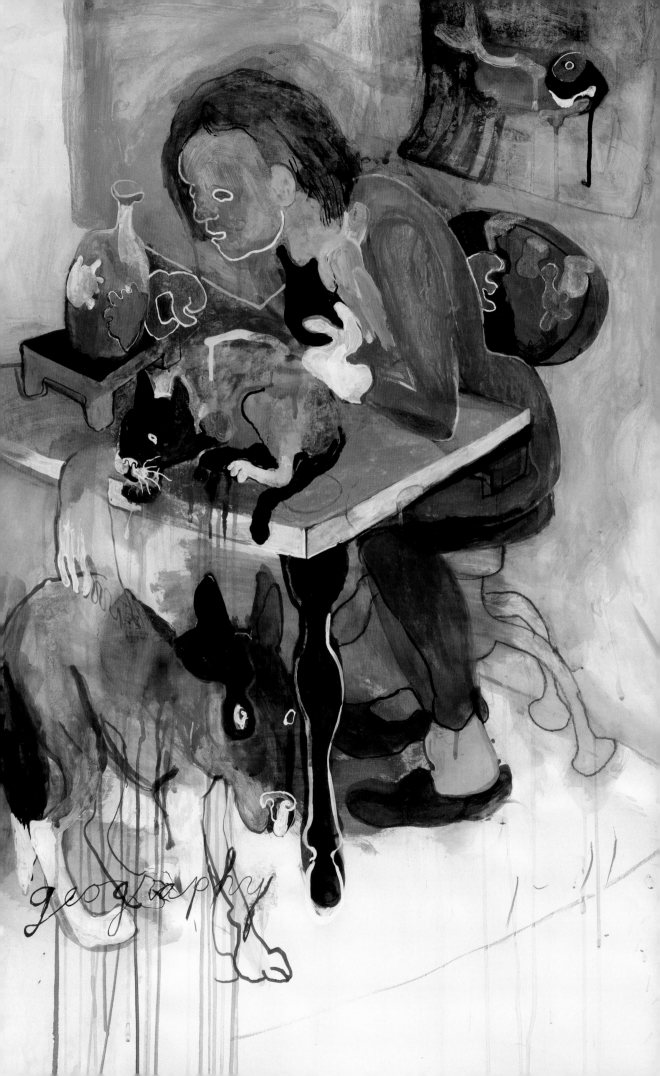

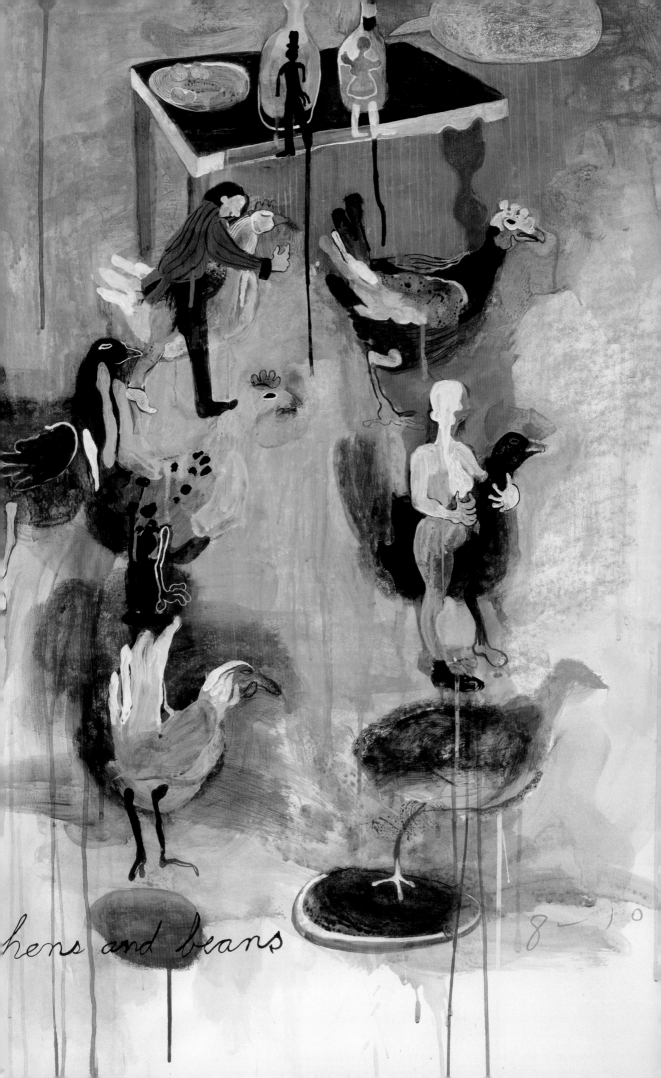

hens and beans

hens and beans
2010
pastel, ink, acrylic on paper
40" x 26"

herders
2010
pastel, ink, acrylic on paper
40" x 26"

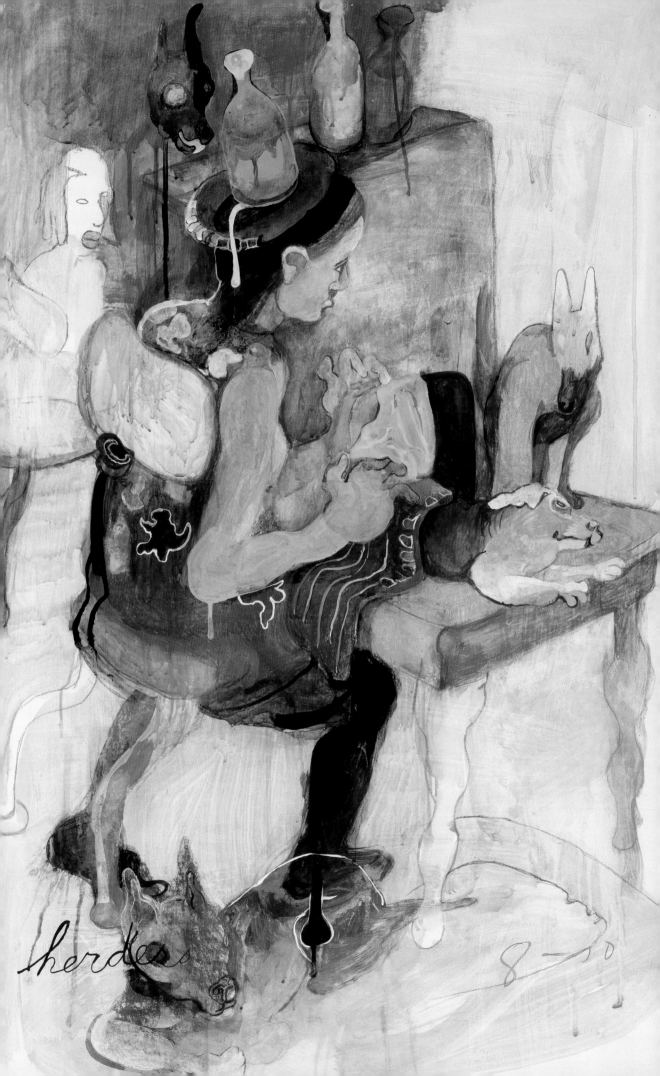

herdess

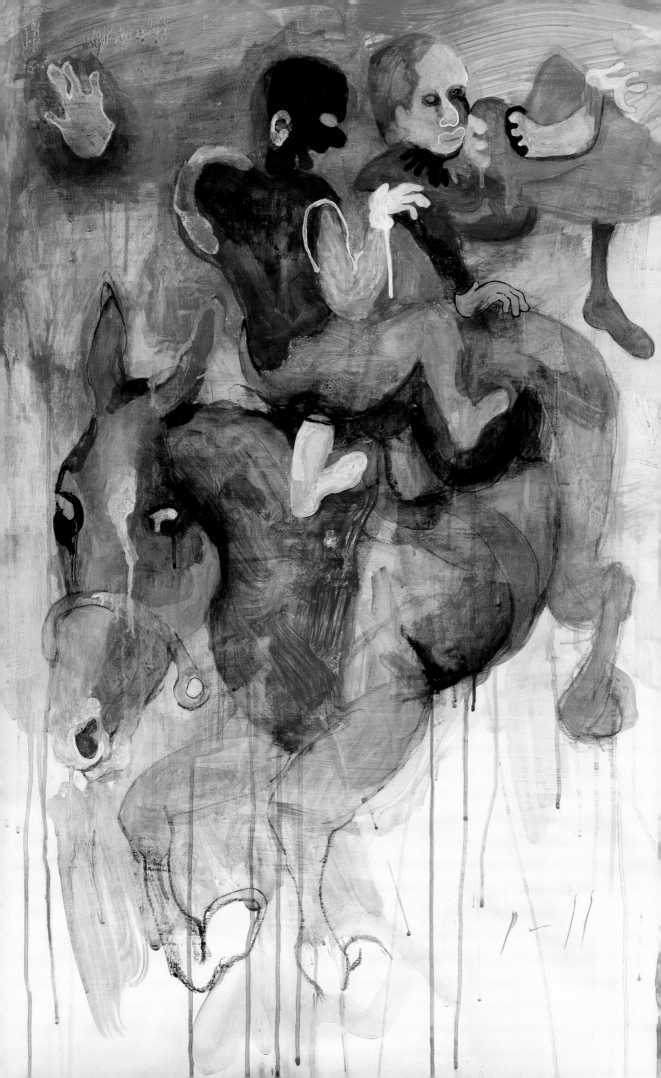

jinn
2011
pastel, ink, acrylic on paper
40" x 26"

My life as a god
2011
pastel, ink, acrylic on paper
40" x 26"

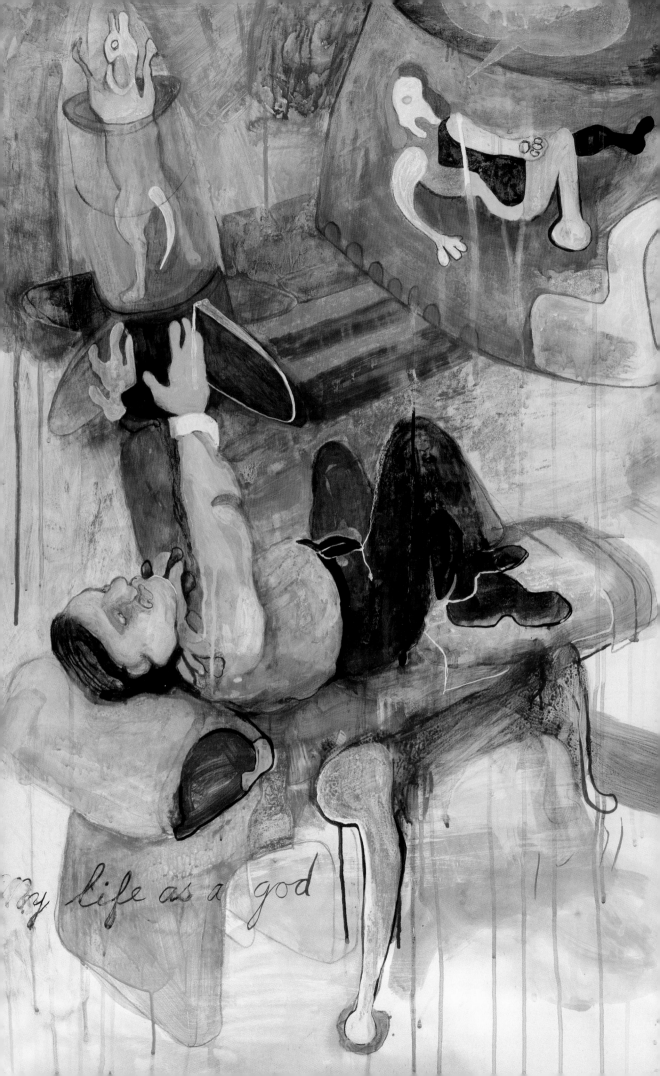

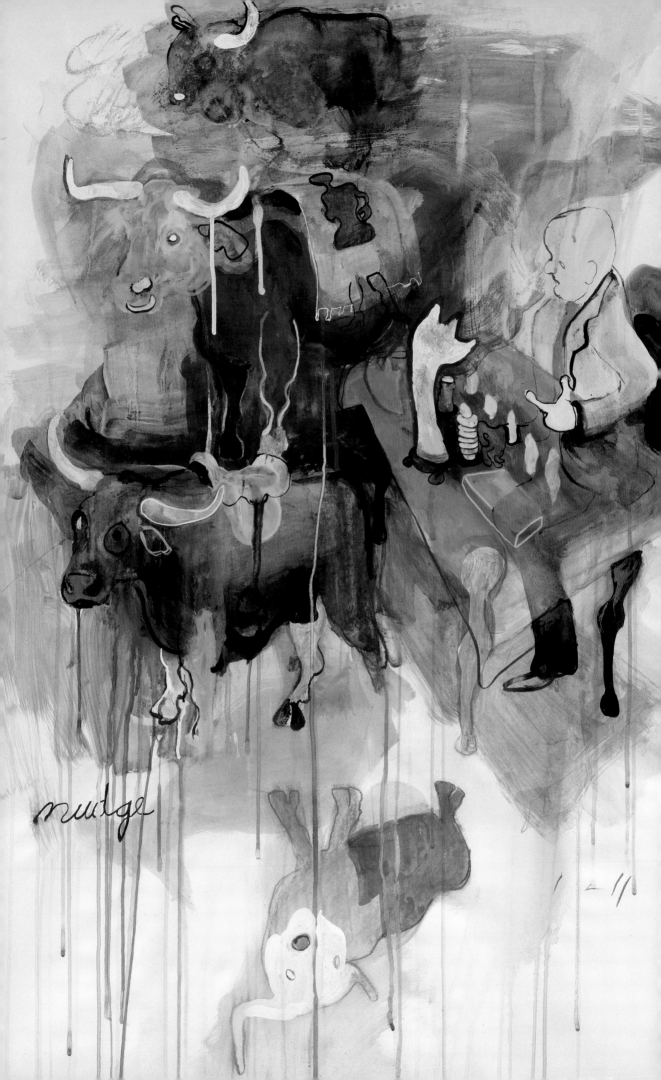

nudge
2011
pastel, ink, acrylic on paper
40" x 26"

off label
2010
pastel, ink, acrylic on paper
40" x 26"

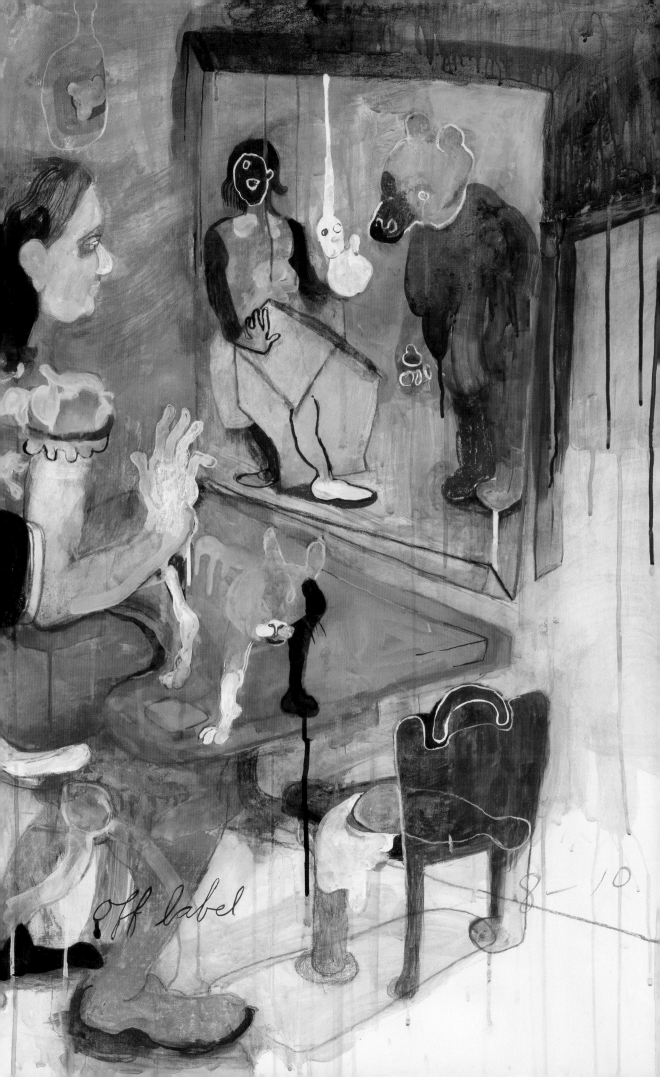

off label

8~10.

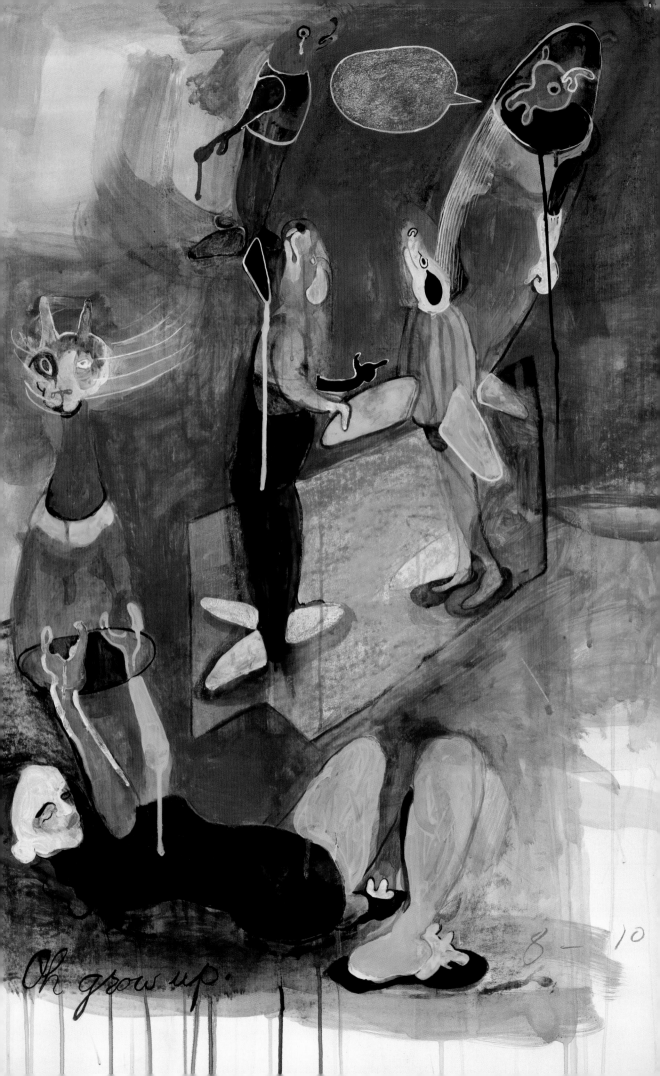

Oh grow up.
2010
pastel, ink, acrylic on paper
40" x 26"

Supper Club
2010
pastel, ink, acrylic on paper
40" x 26"

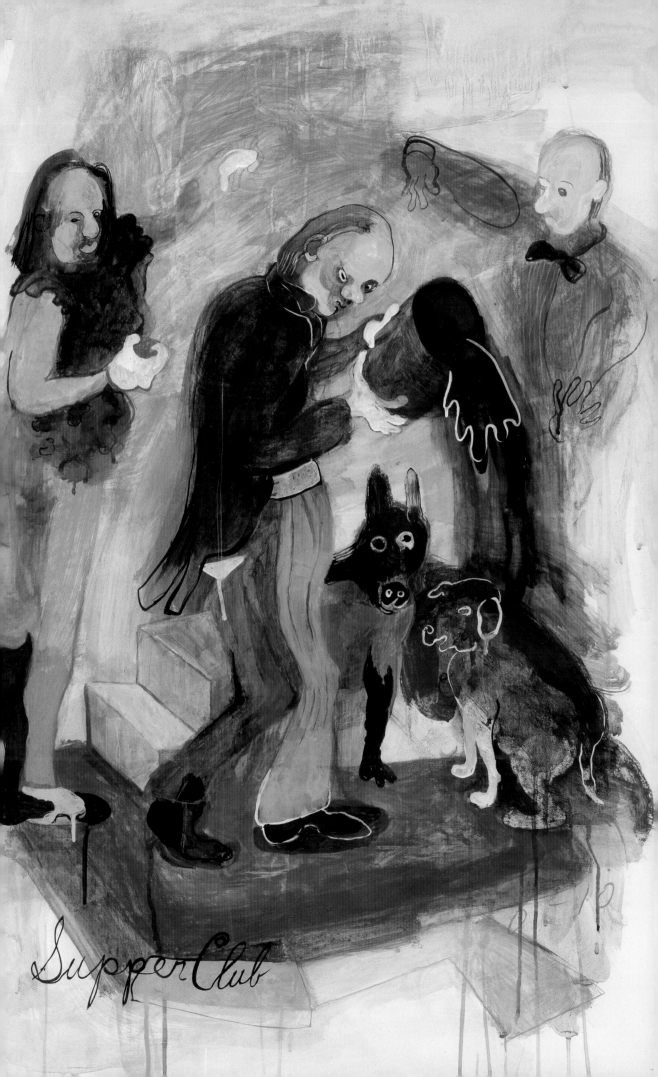

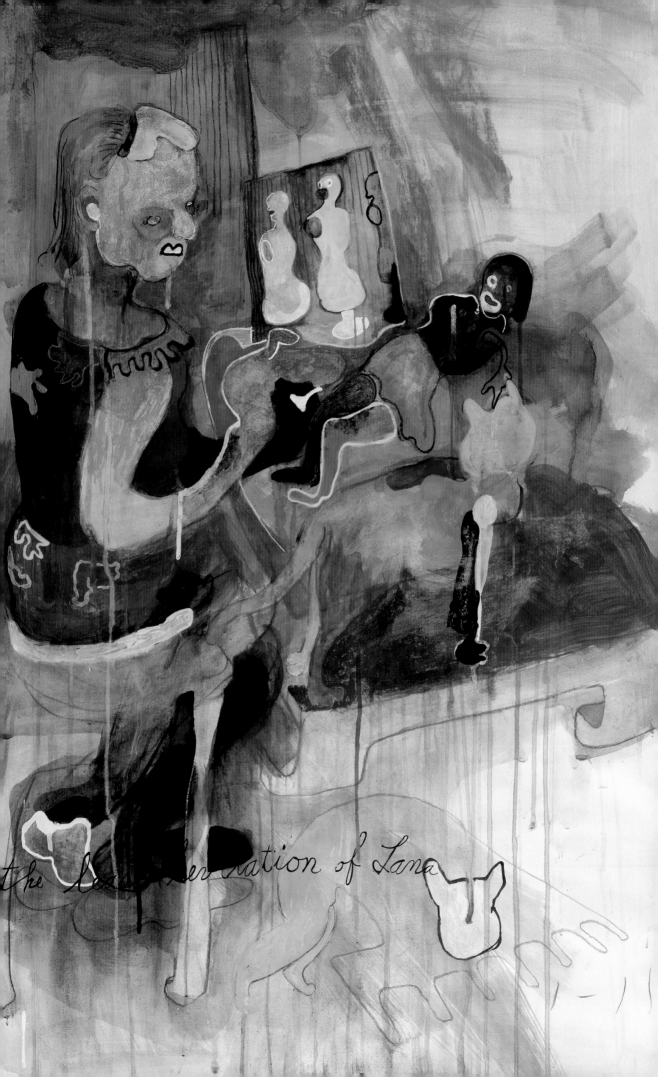

the *lost* servation of Lana

the least levitation of Lana
2011
pastel, ink, acrylic on paper
40" x 26"

*The year we kept finding
mice in our soup*
2010
pastel, ink, acrylic on paper
40" x 26"

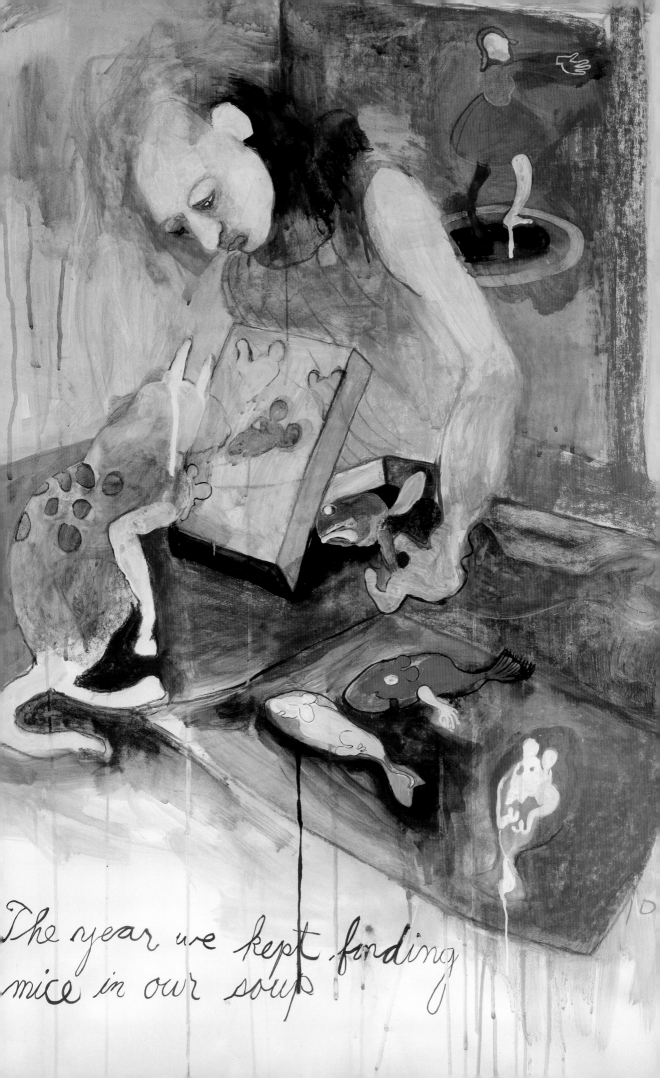

The year we kept finding
mice in our soup

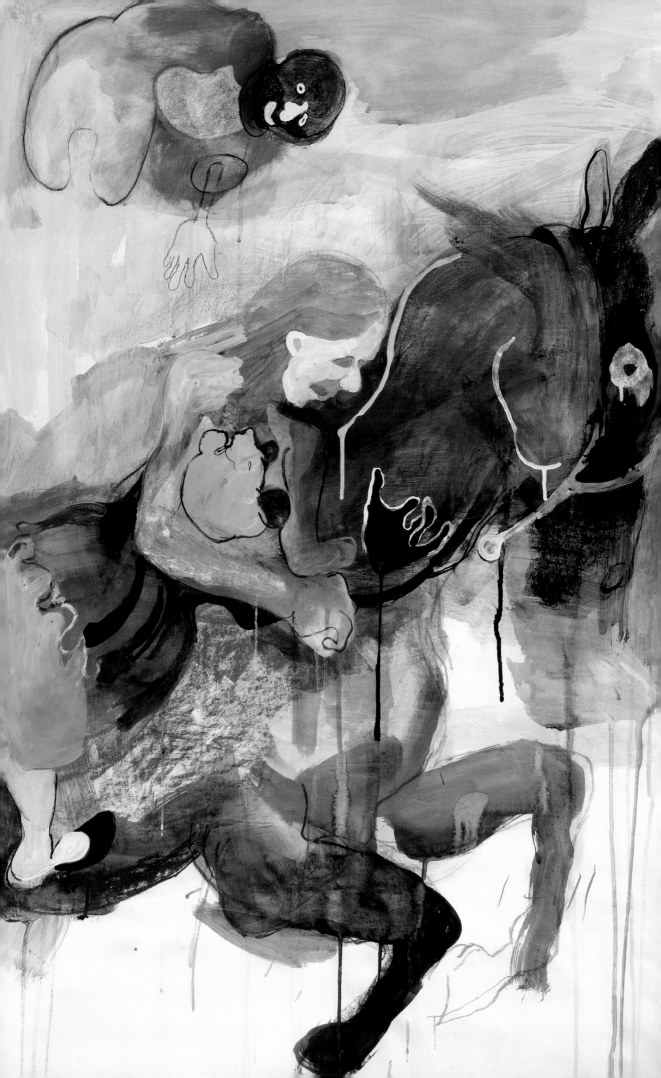

untitled *(yellow bear)*
2011
pastel, ink, acrylic on paper
40" x 26"

vitrine
2011
pastel, ink, acrylic on paper
40" x 26"

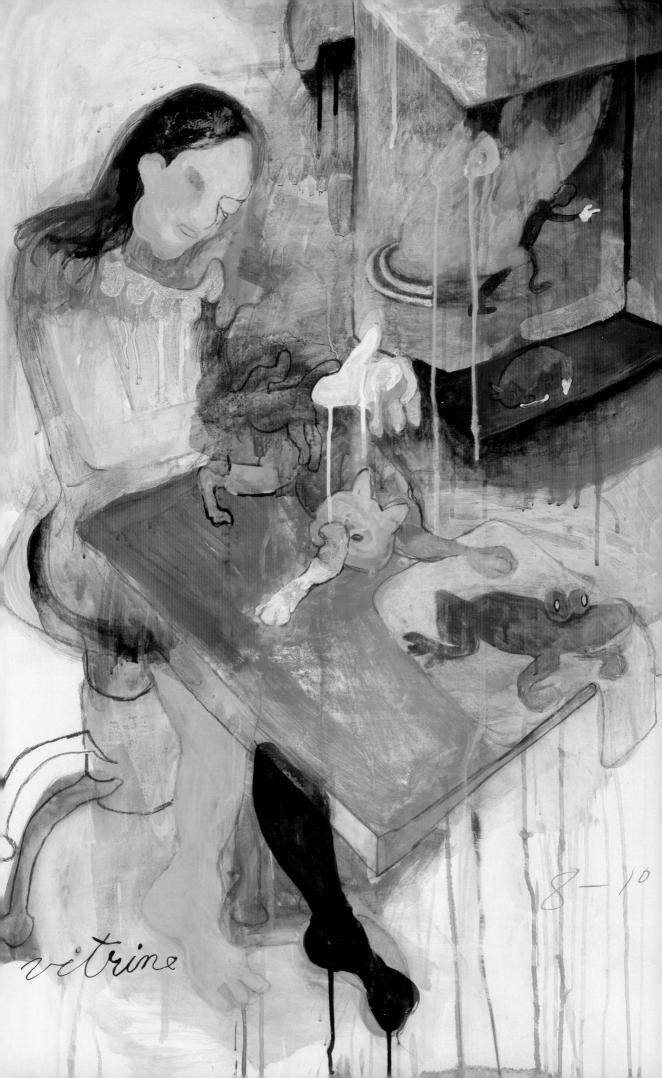

vitrine

8—10

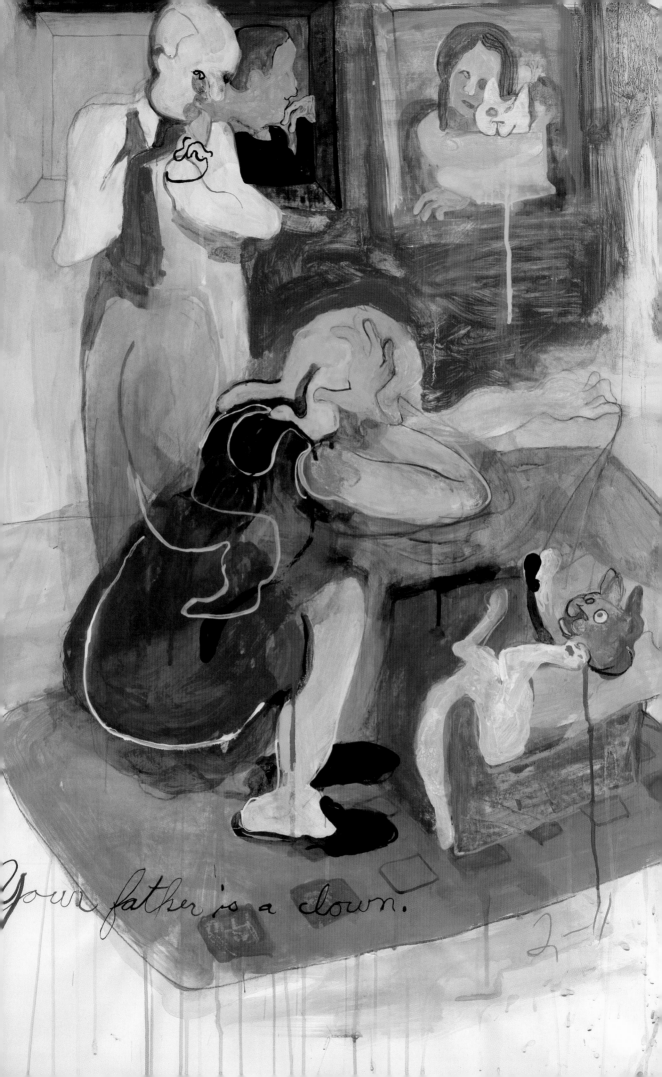

Your father is a clown.

Your father is a clown.
2011
pastel, ink, acrylic on paper
40" x 26"

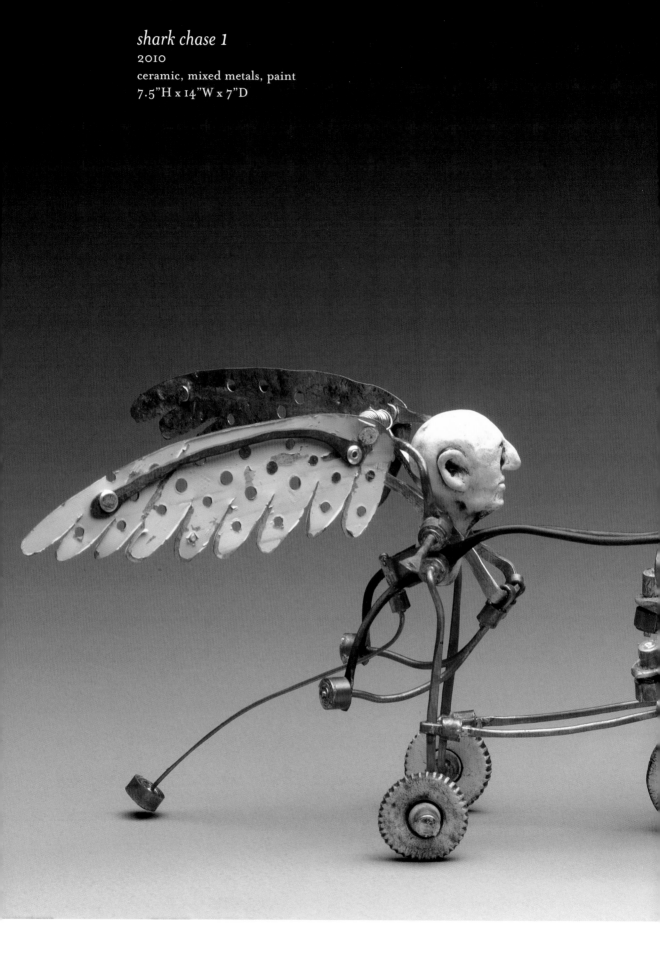

shark chase 1
2010
ceramic, mixed metals, paint
7.5"H x 14"W x 7"D

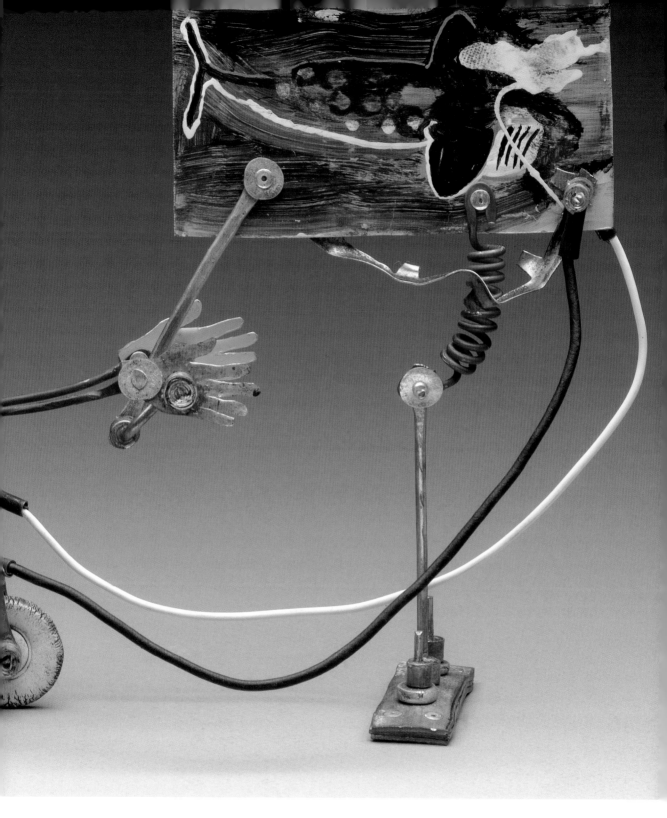

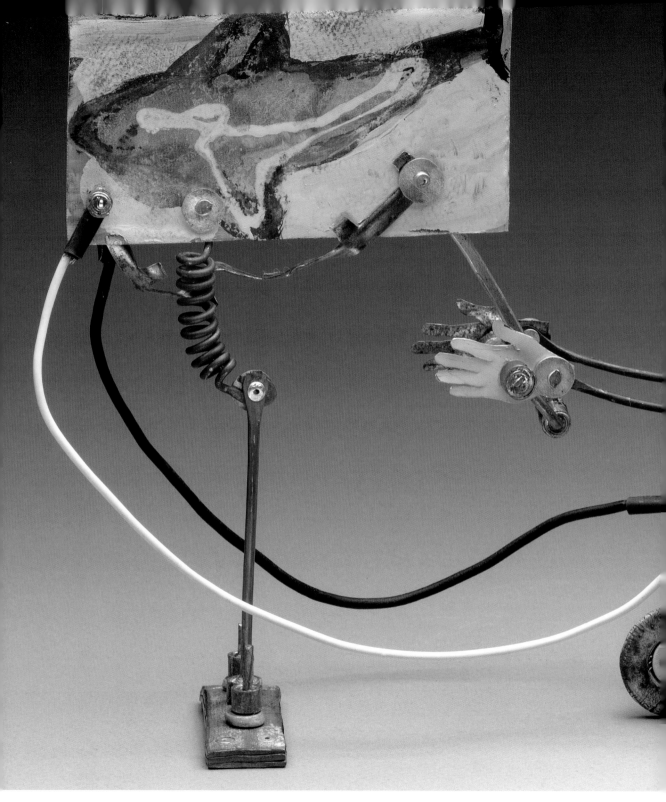

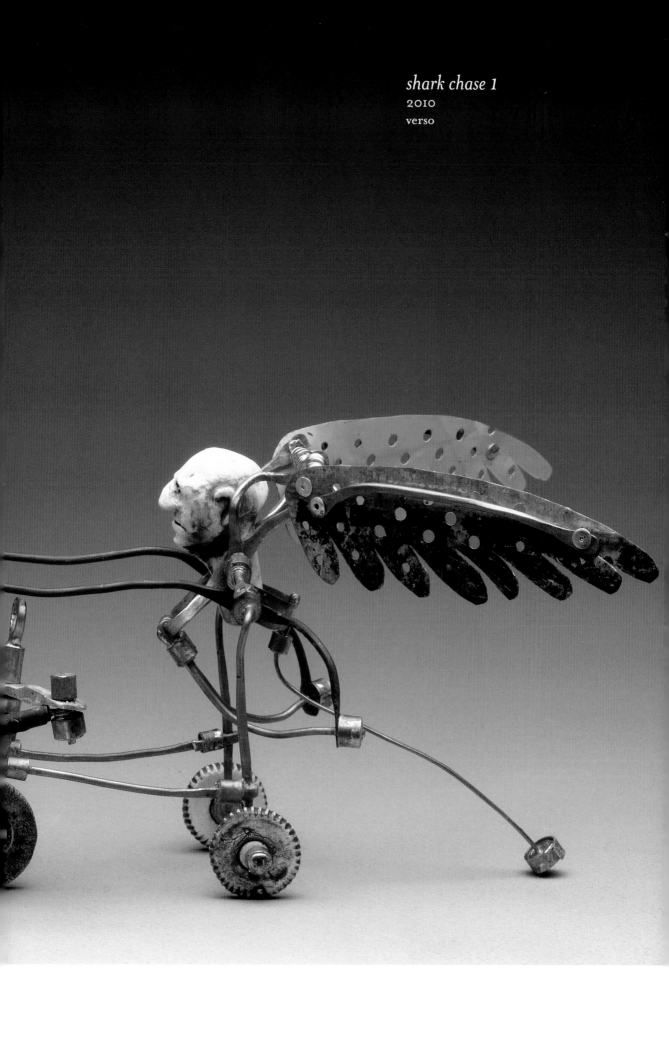

shark chase 1
2010
verso

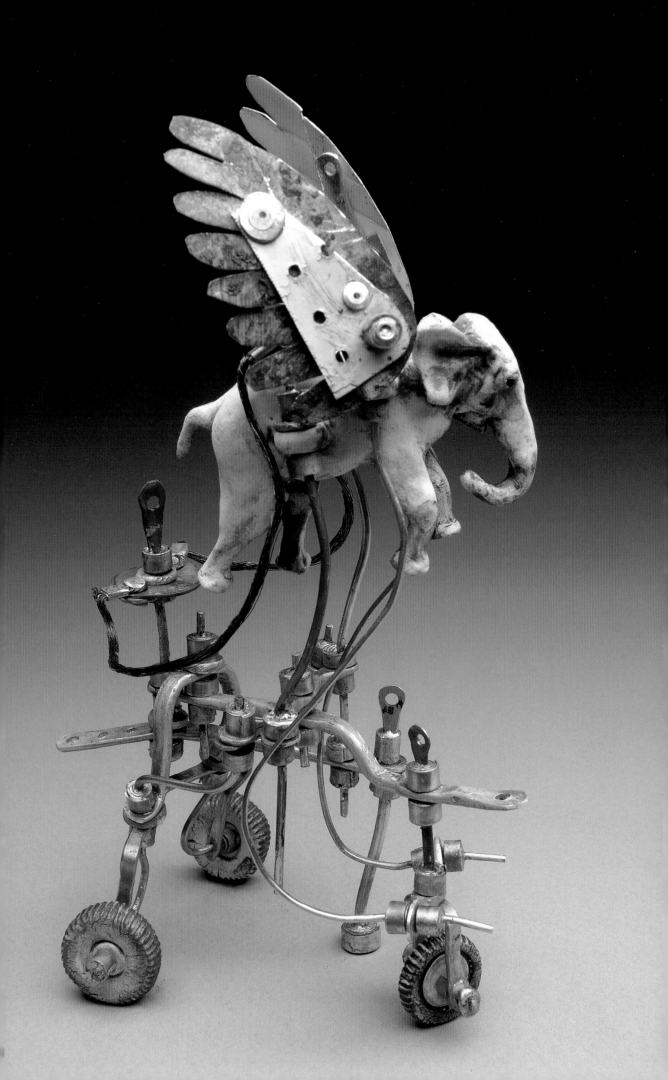

another heaven
2011
ceramic, mixed metals, paint
8"H x 5.5"W x 3.5"D

bookity book
2010
ceramic, mixed metals, concrete, paint
15"H x 14"W x 10"D

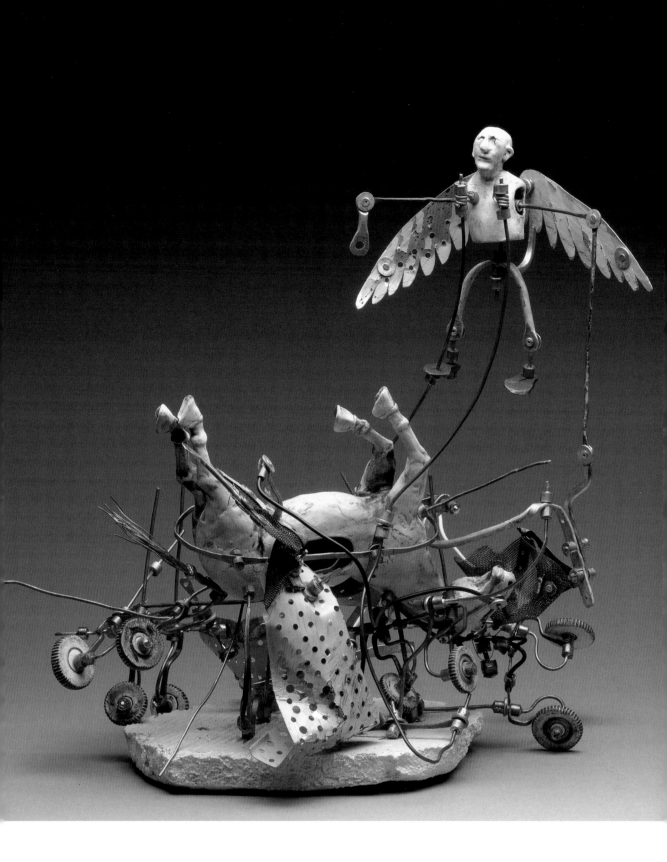

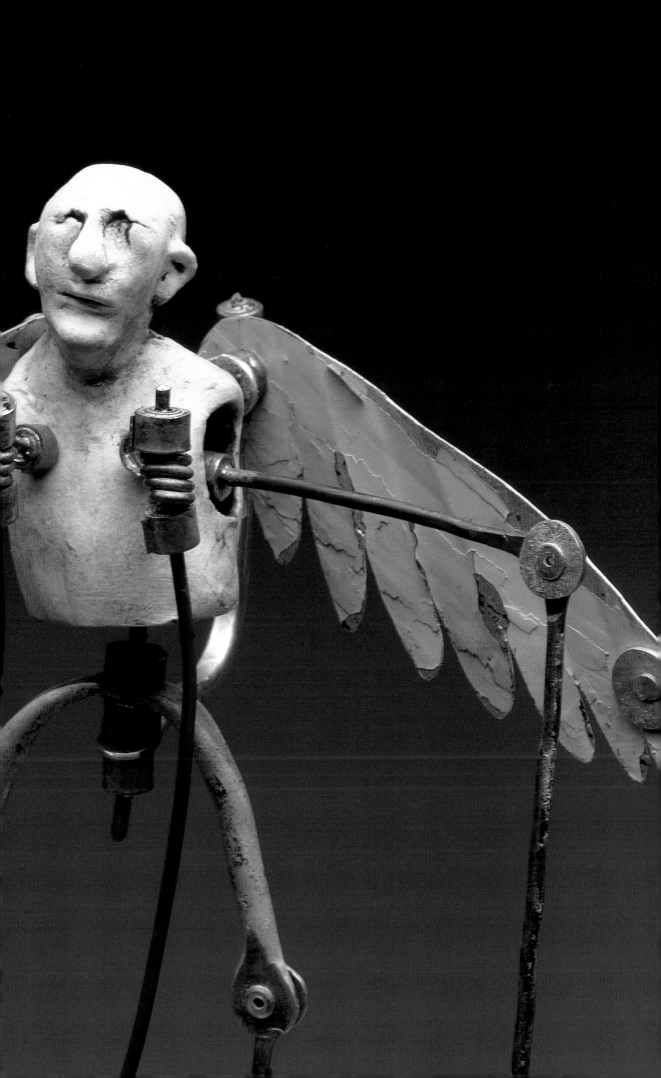

brainchild
2011
ceramic, mixed metals, paint
10"H x 8"W x 8"D

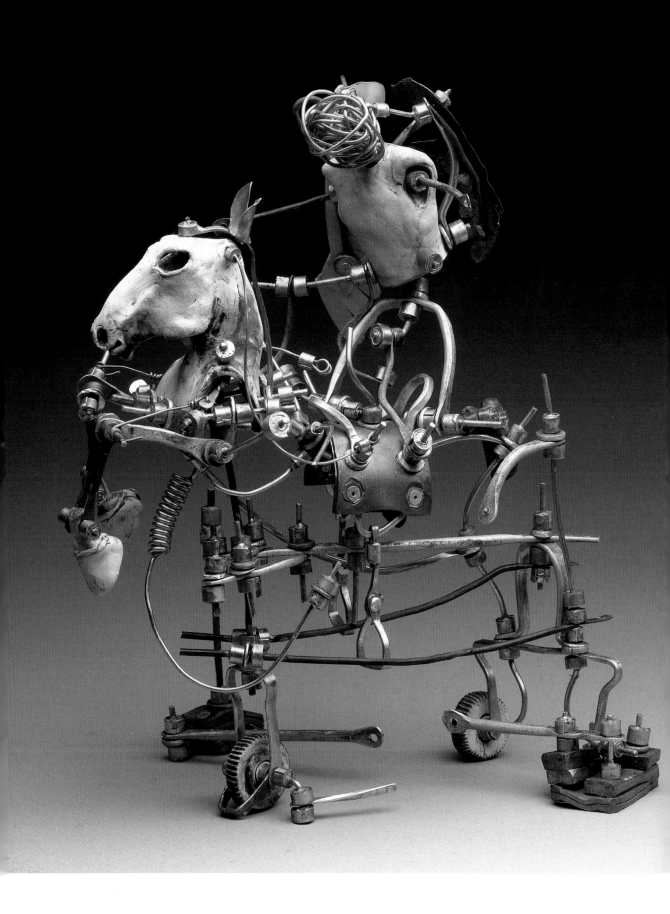

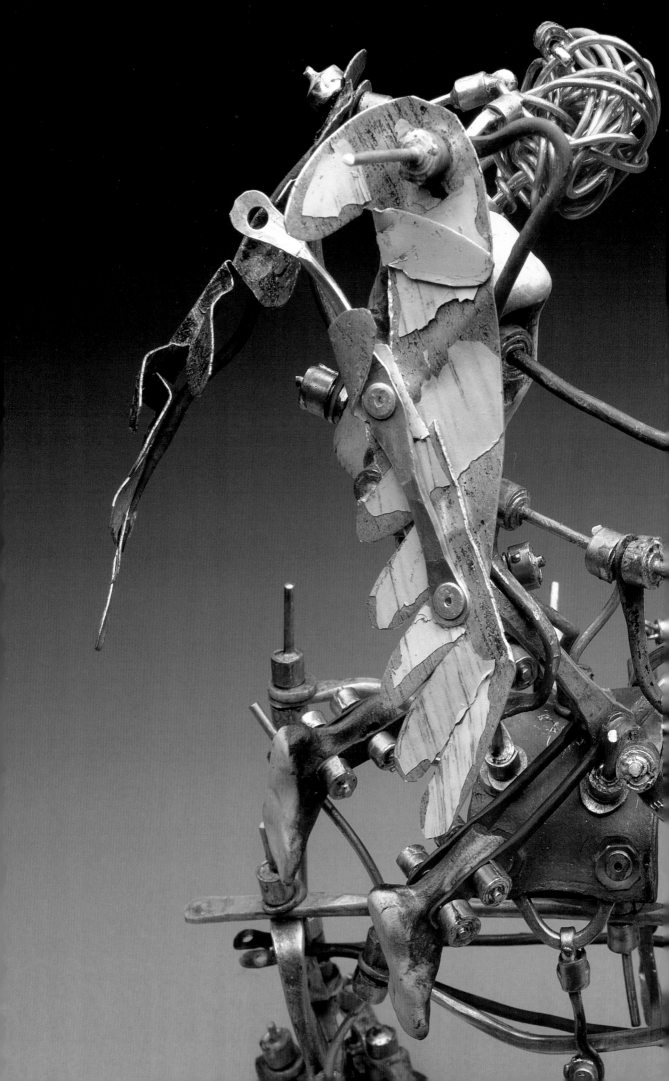

brainchild
detail

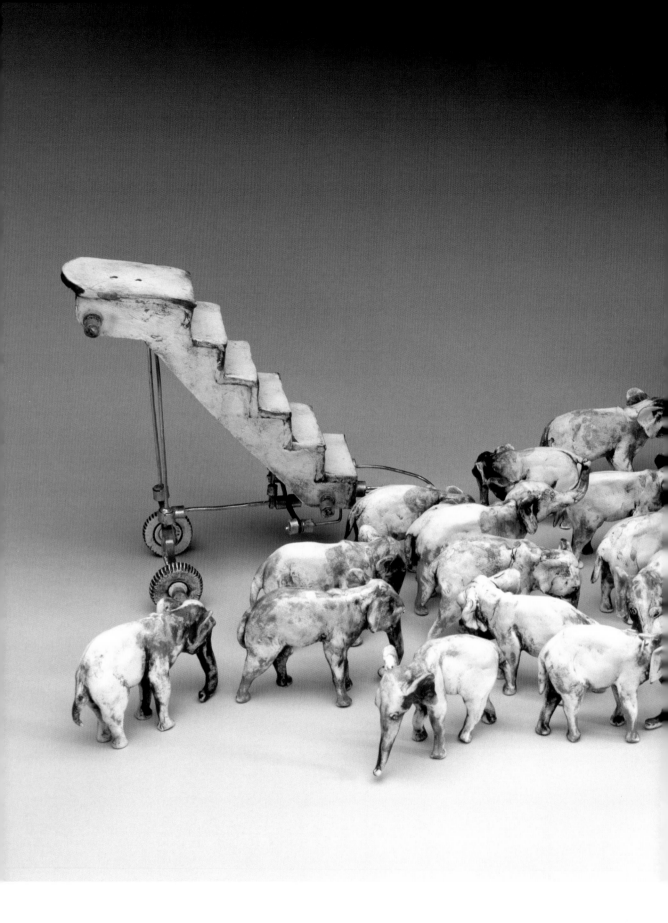

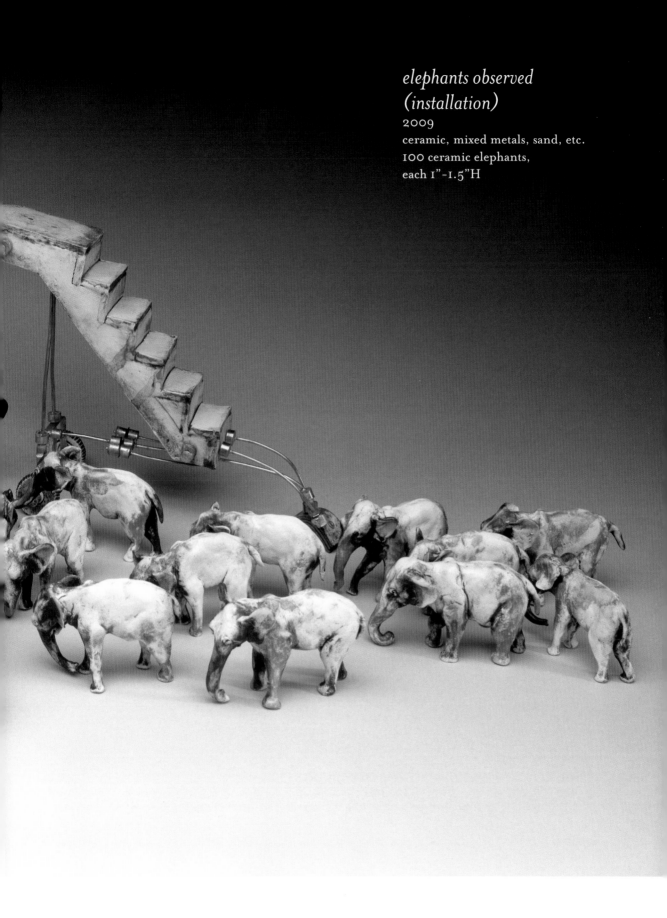

*elephants observed
(installation)*
2009
ceramic, mixed metals, sand, etc.
100 ceramic elephants,
each 1"-1.5"H

feathers or
'the early clone gets the contract.'
2005
ceramic, mixed metals
10"H x 12"W x 8"D

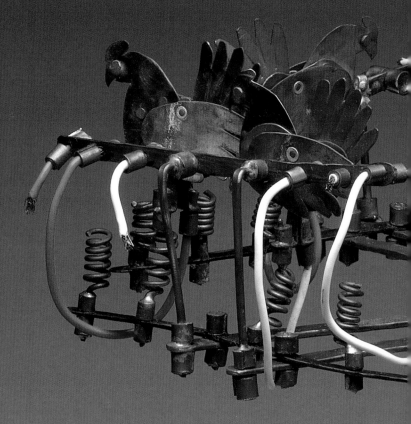

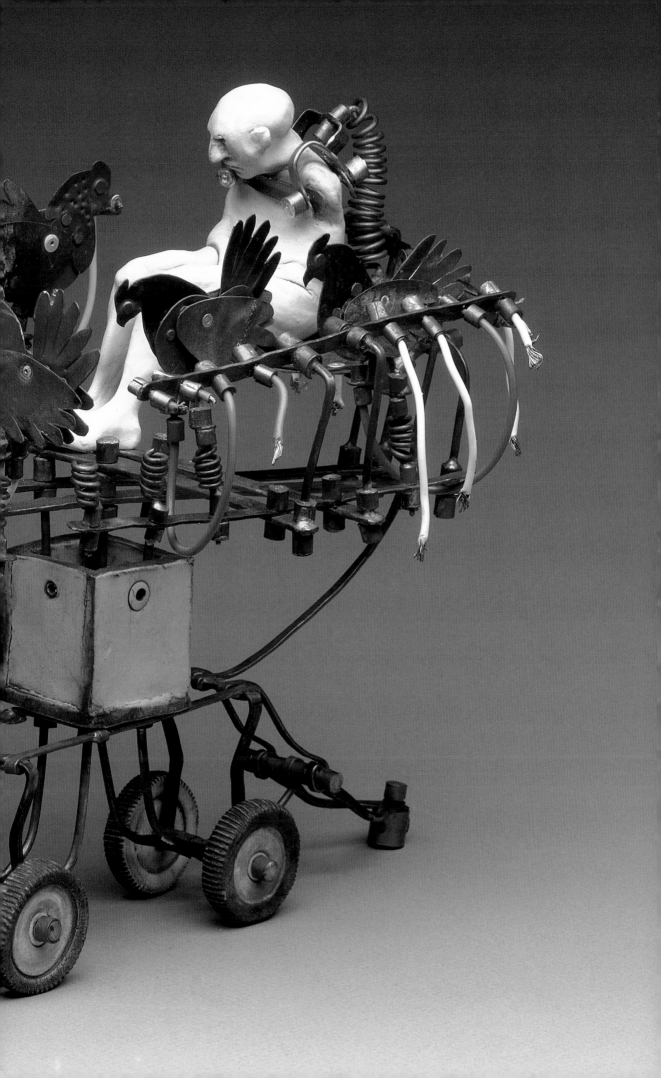

fly's first word
2011
ceramic, mixed metals, paint
14"H x 12"W x 8"D

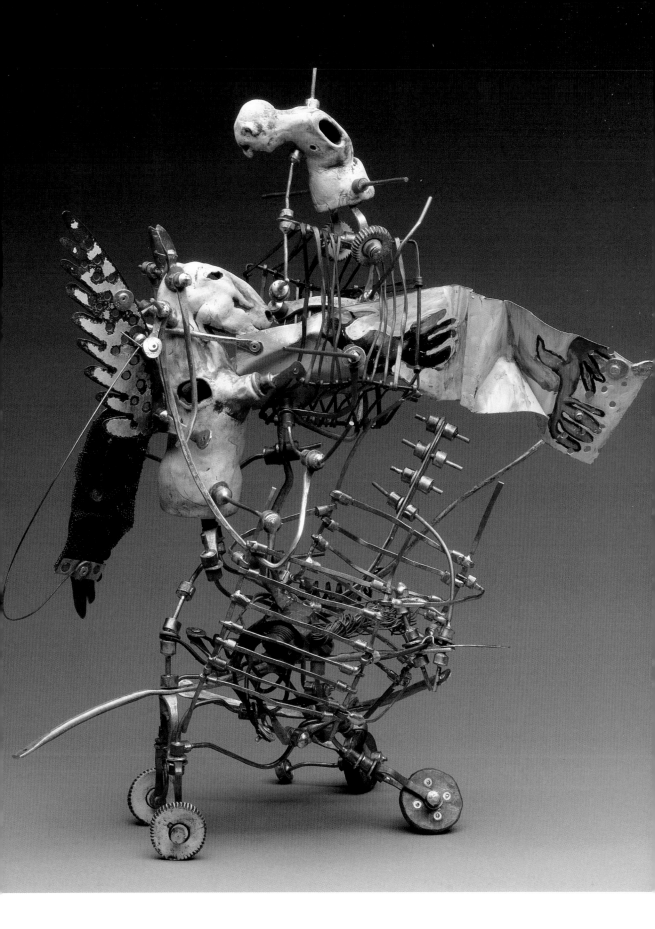

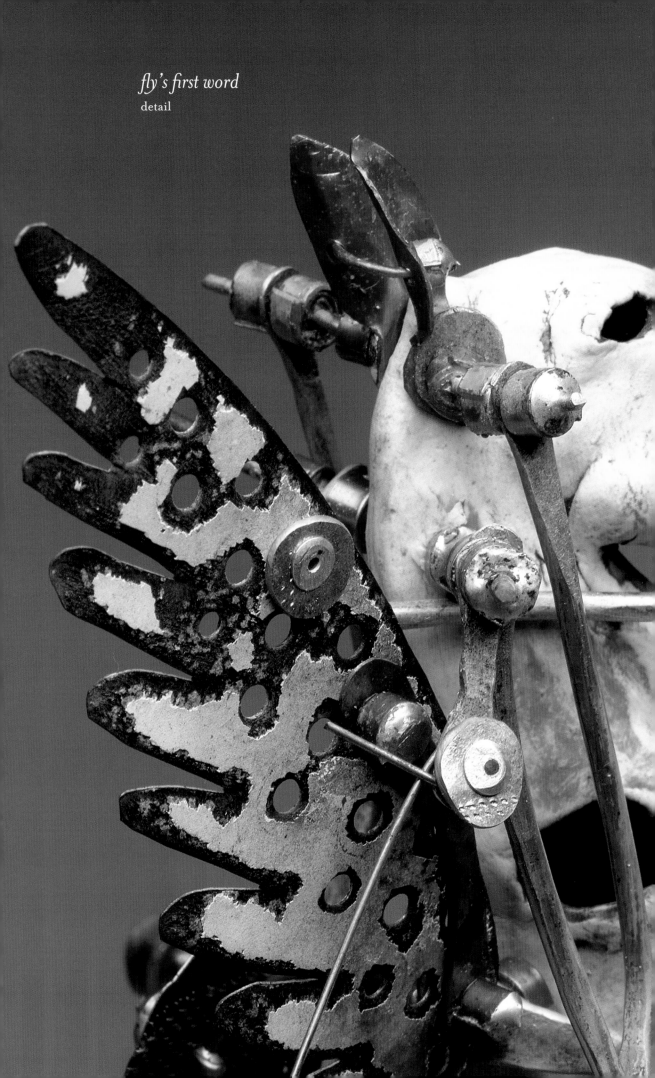

fly's first word
detail

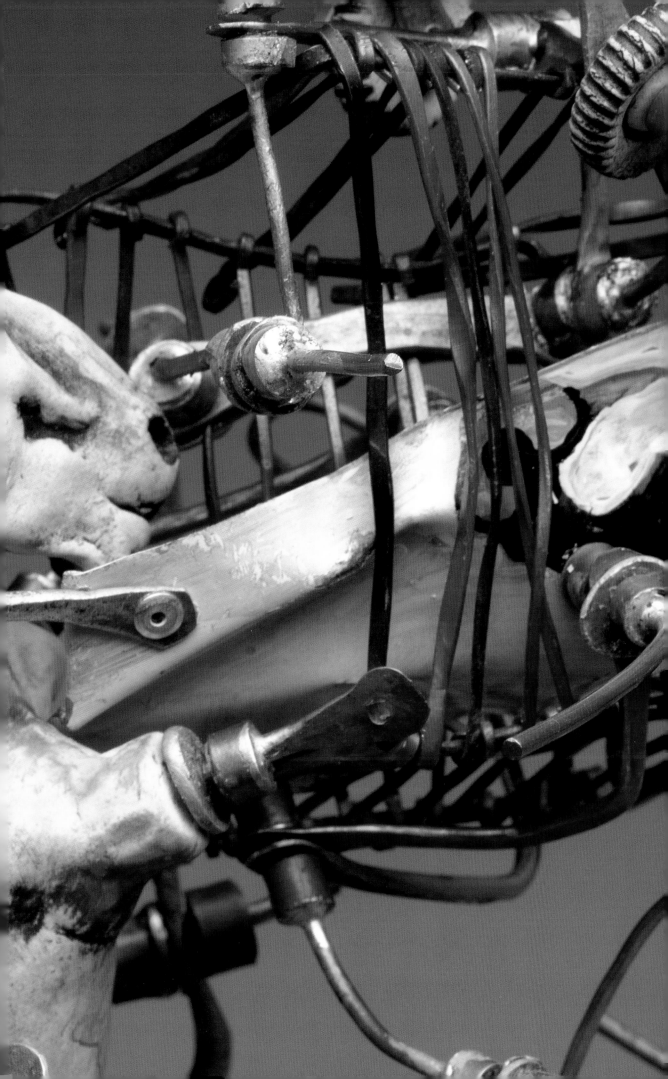

fully-funded rover
2010
ceramic, mixed metals, paint
12.5"H x 11"W x 7.5"D

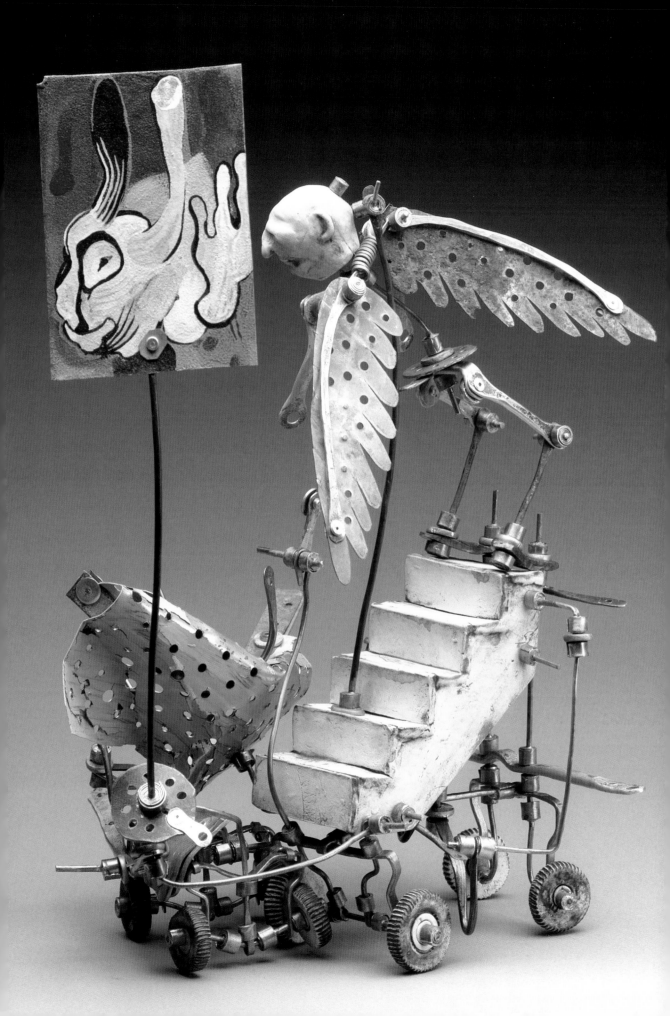

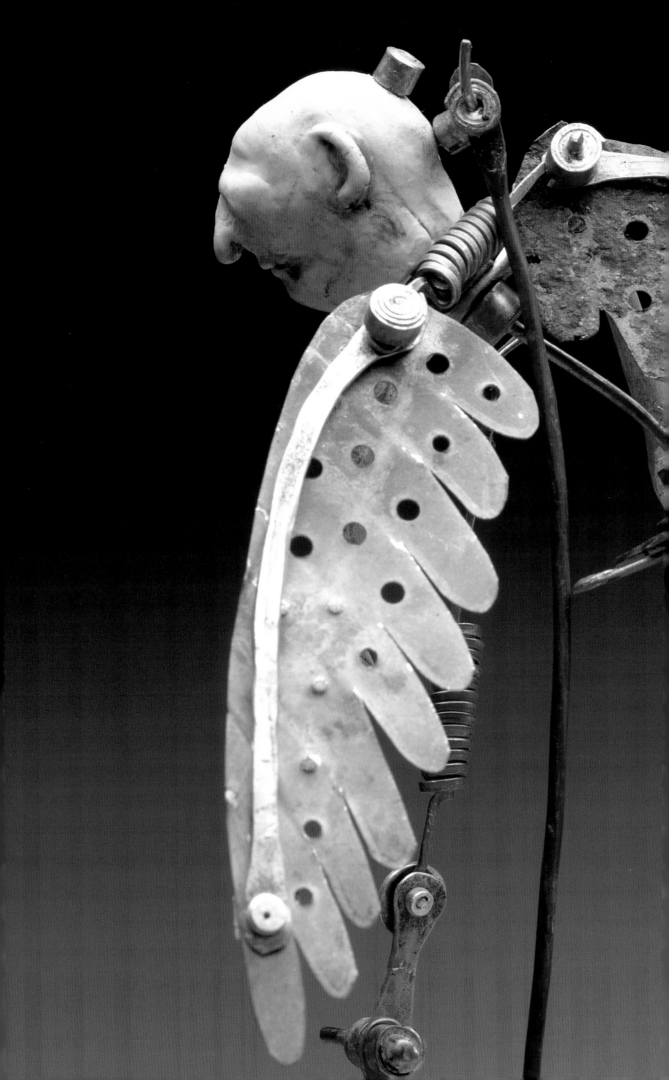

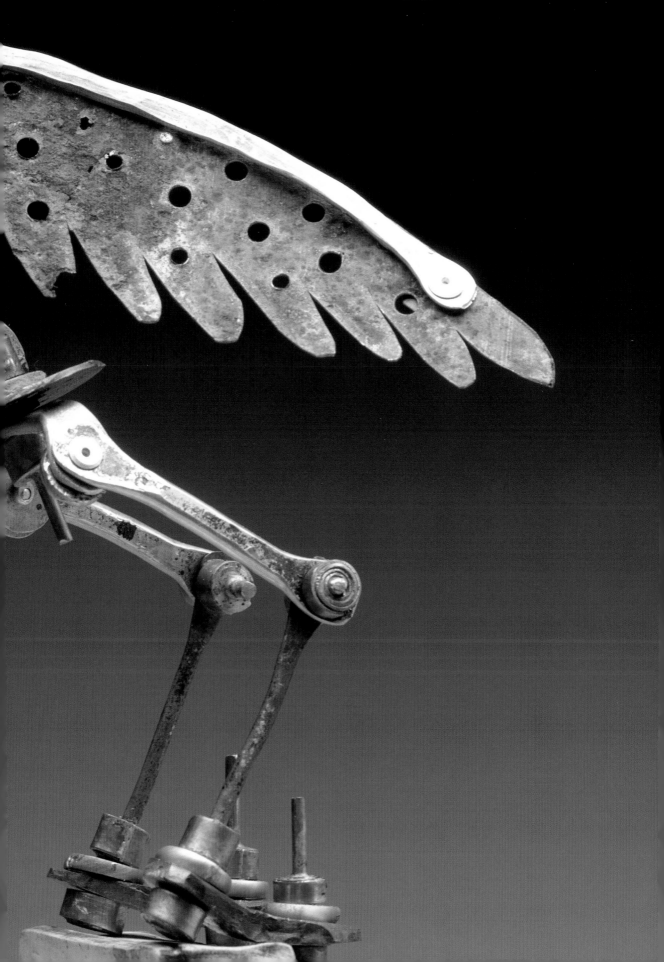

fully-funded rover
detail

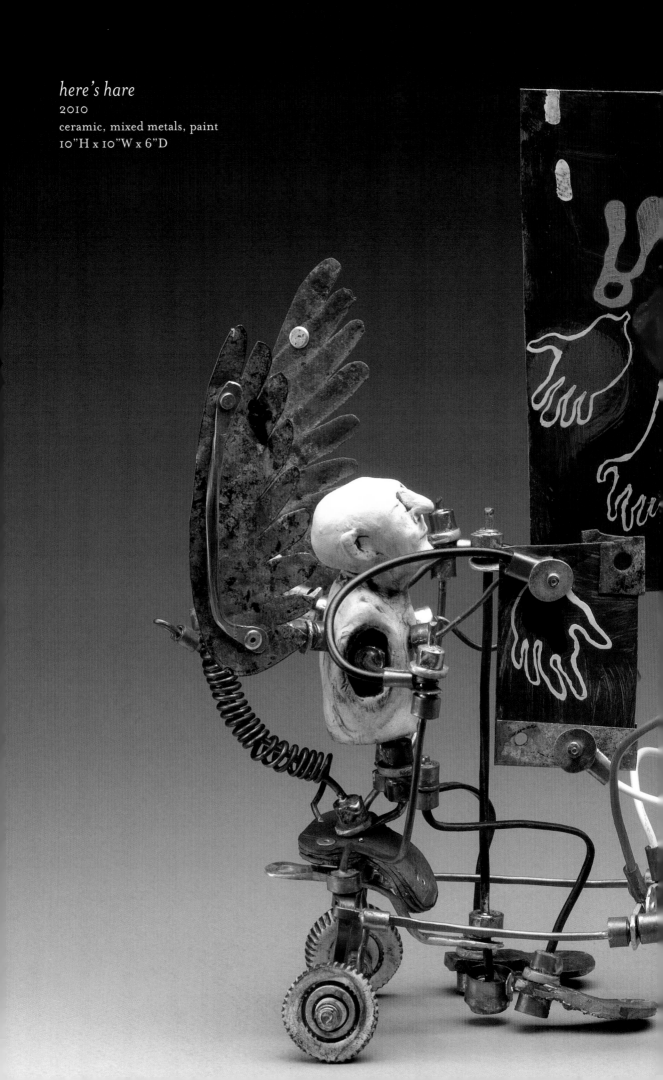

here's hare
2010
ceramic, mixed metals, paint
10"H x 10"W x 6"D

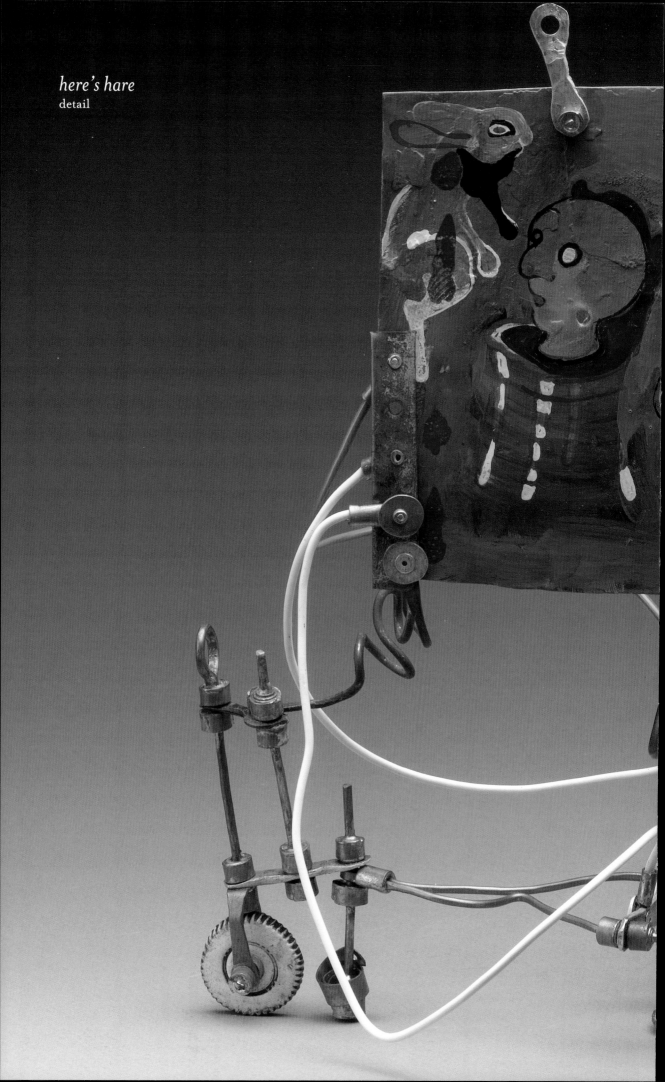

here's hare
detail

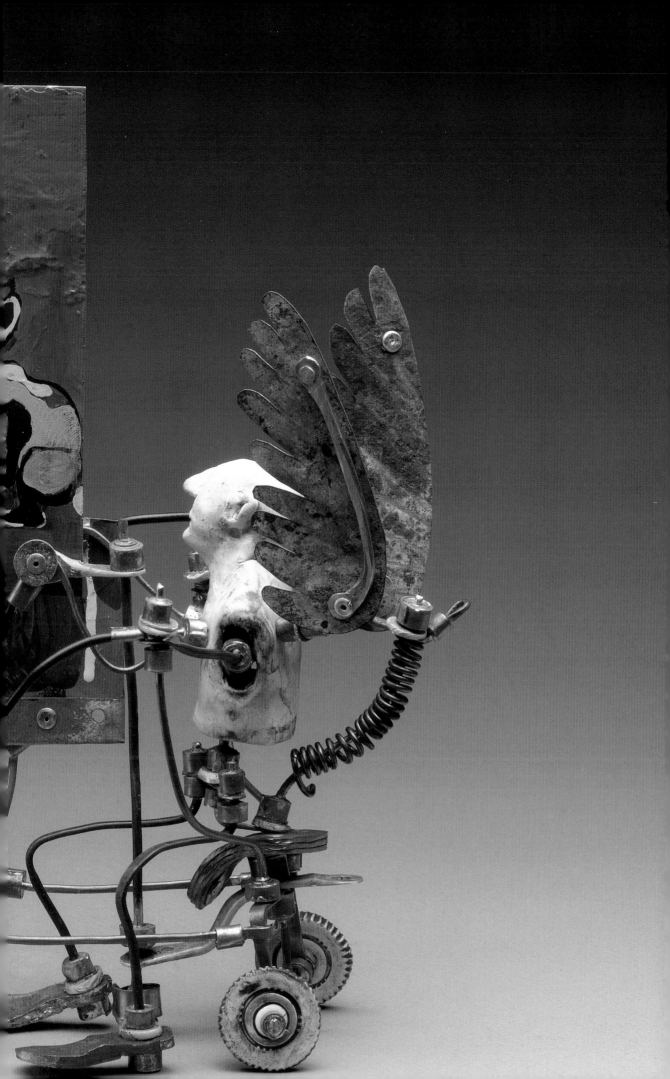

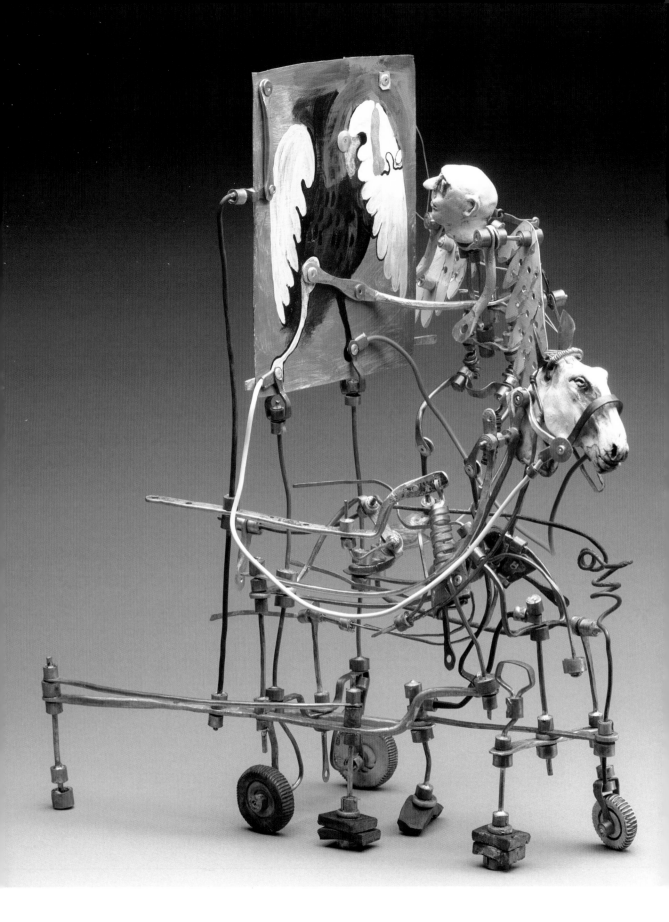

later him soar
2010
ceramic, mixed metals, paint
13.5"H x 12"W x 8"D

loom
2009
ceramic, mixed metals
14.5"H x 14"W x 9"D

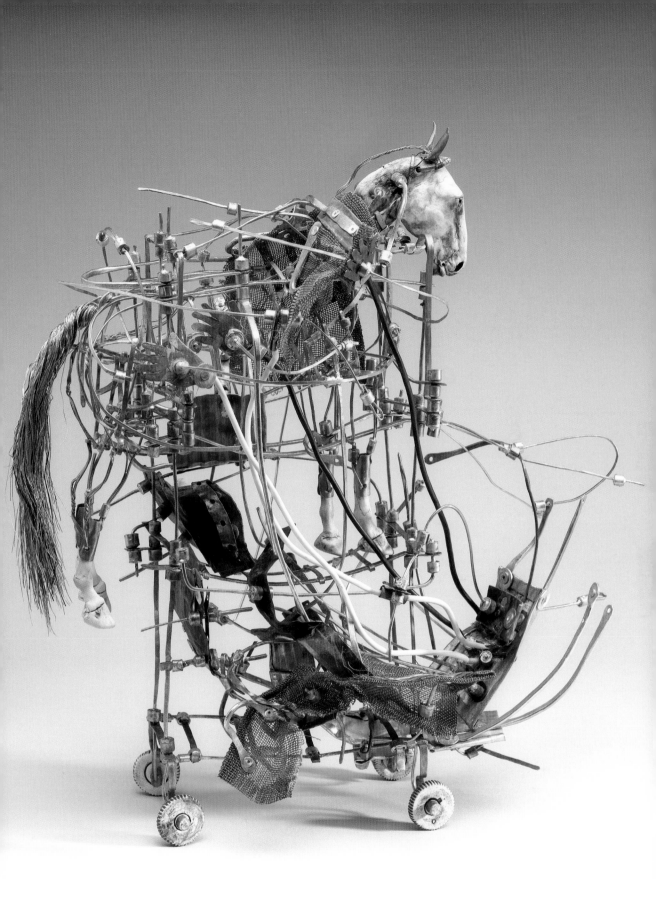

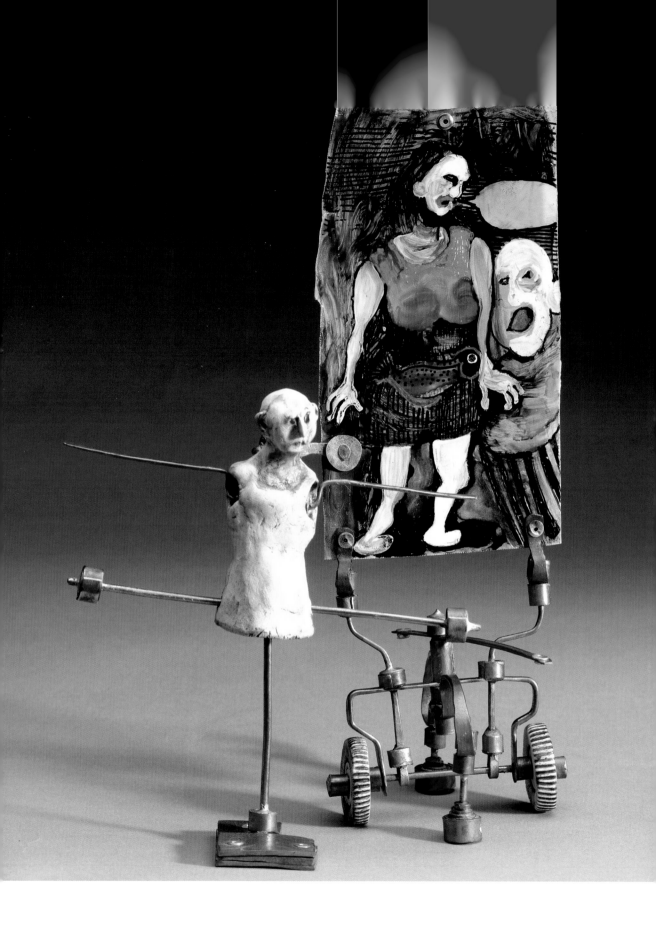

red in fashion
2009
ceramic, mixed metals, paint
9.5"H x 7"W x 4"D

referee
2009
ceramic, mixed metals, paint
9.5"H x 7"W x 6"D

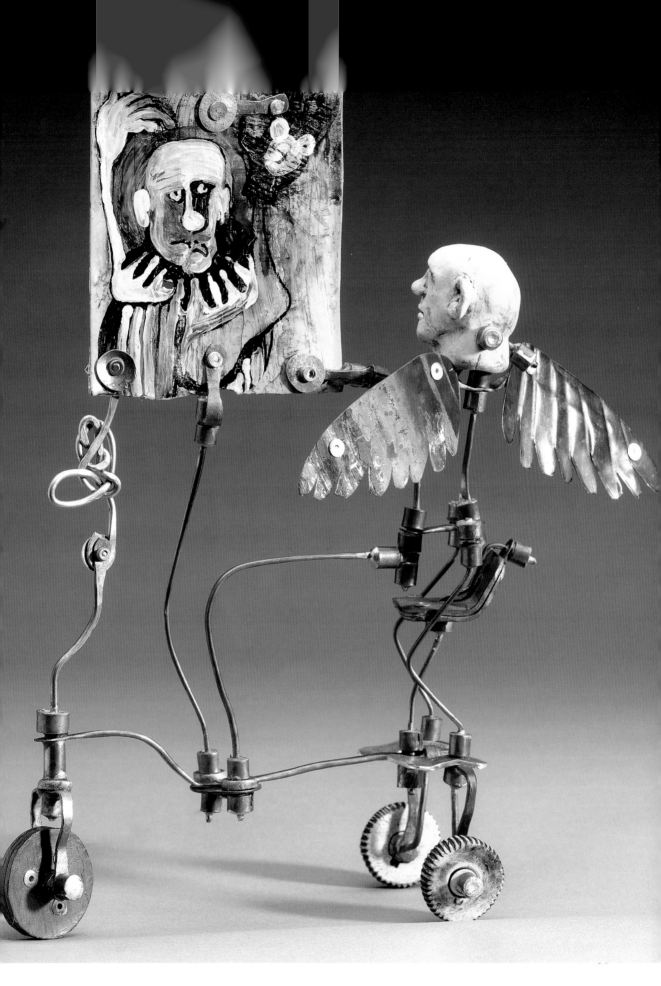

airplane one
2010
ceramic, mixed metals, concrete, paint
14"H x 11"W x 7"D

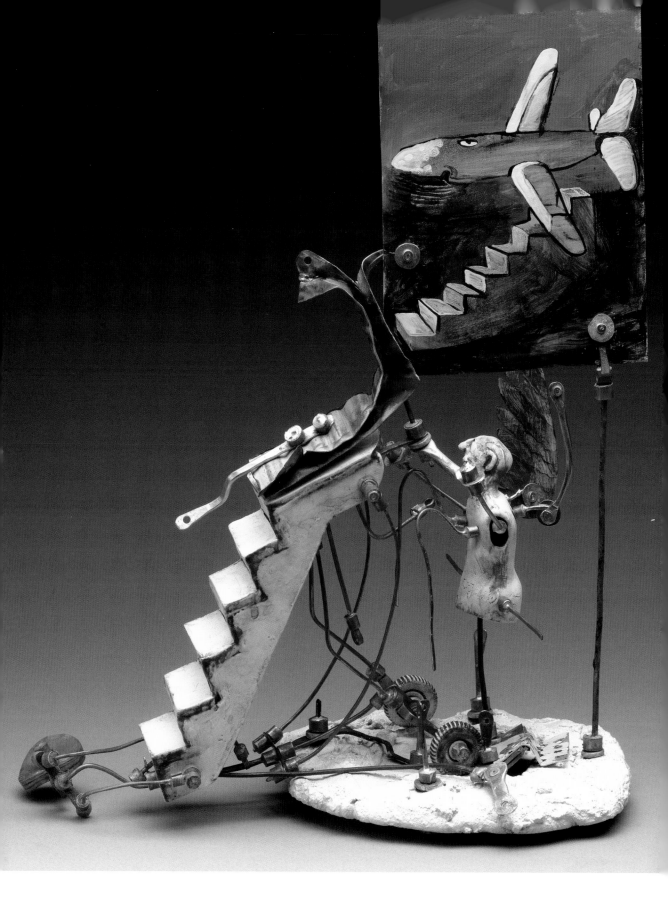

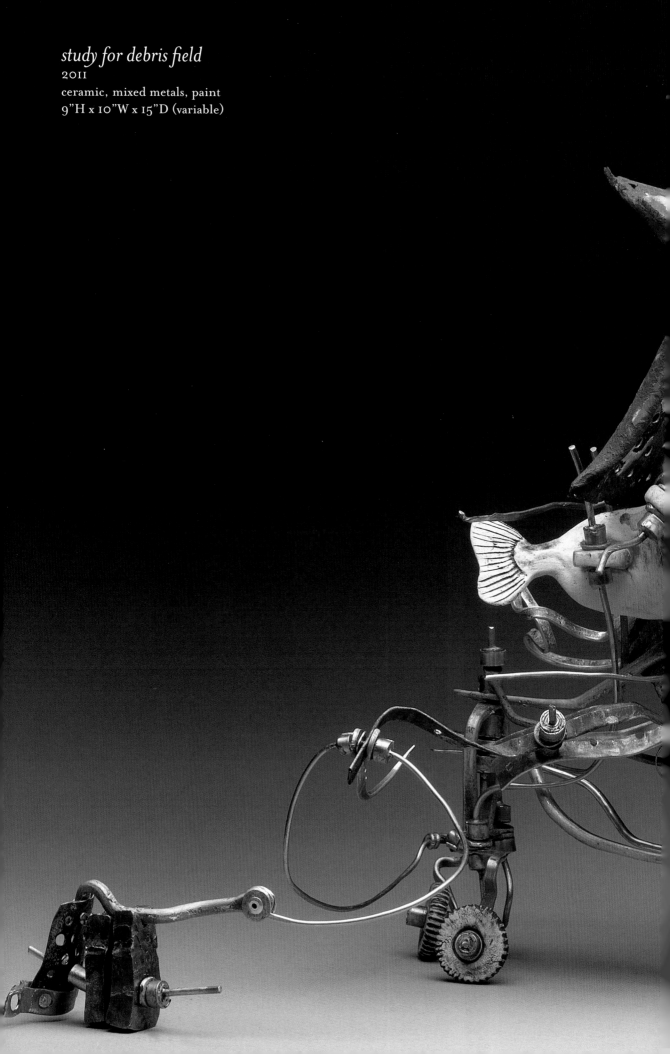

study for debris field
2011
ceramic, mixed metals, paint
9"H x 10"W x 15"D (variable)

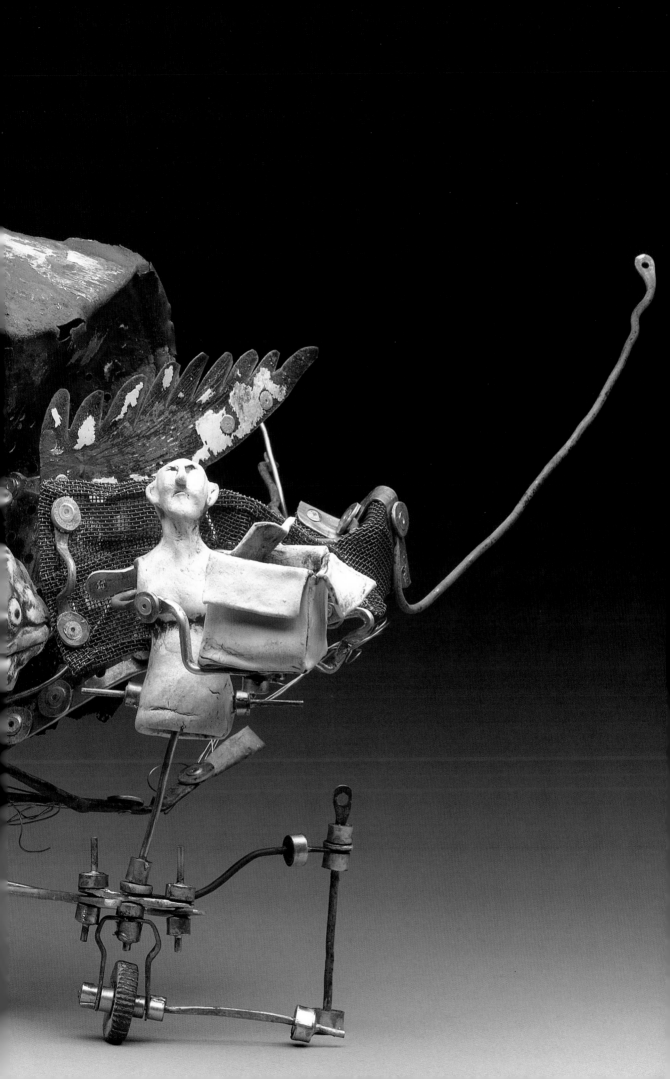

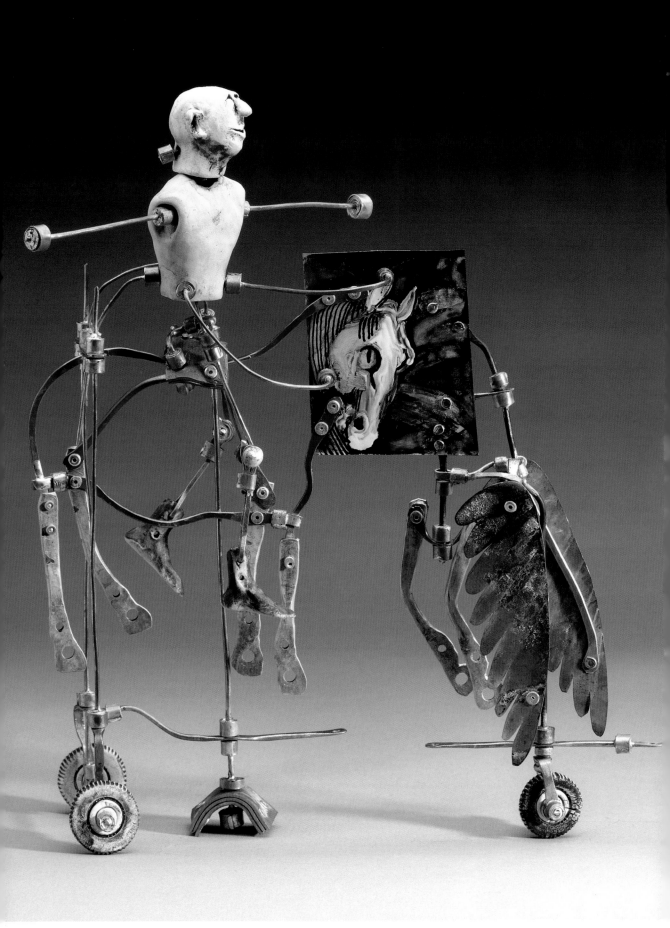

ticker's foal
2009
ceramic, mixed metals, paint
12"H x 11"W x 5"D

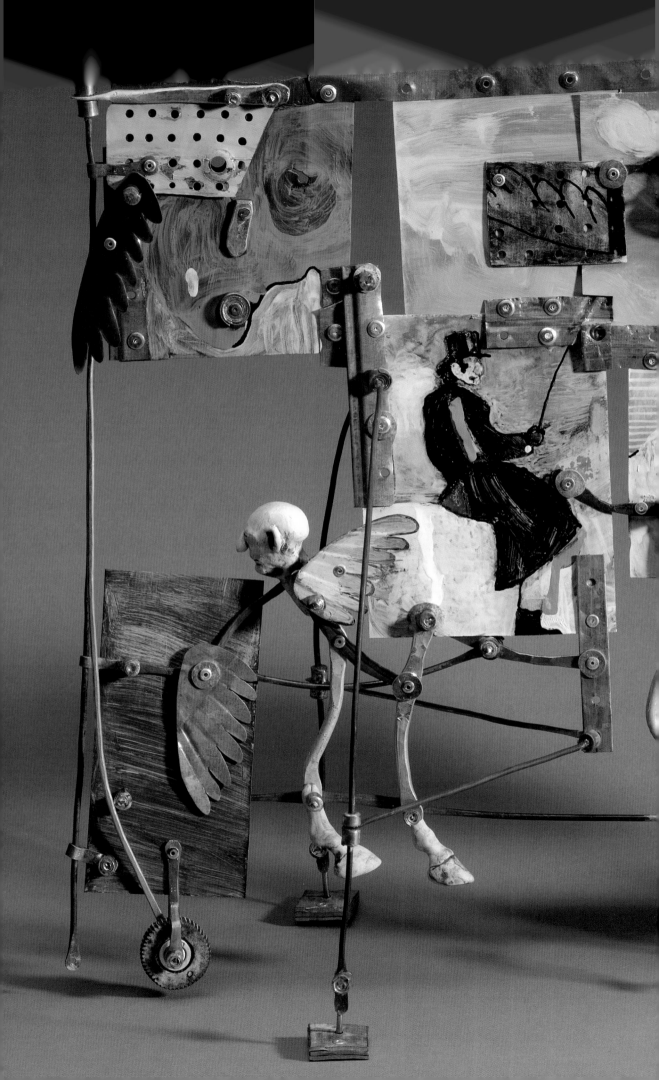

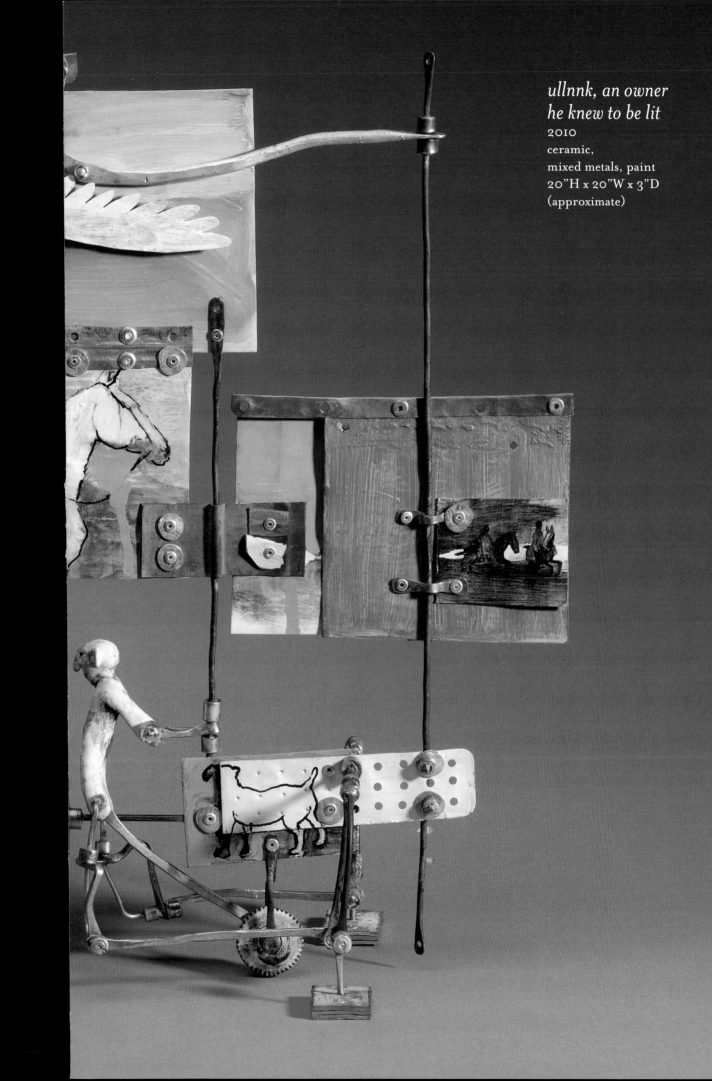

*ullnnk, an owner
he knew to be lit*
2010
ceramic,
mixed metals, paint
20"H x 20"W x 3"D
(approximate)

who will keep the keepers themselves?
2009
ceramic, mixed metals
9.5"H x 10"W x 6"D

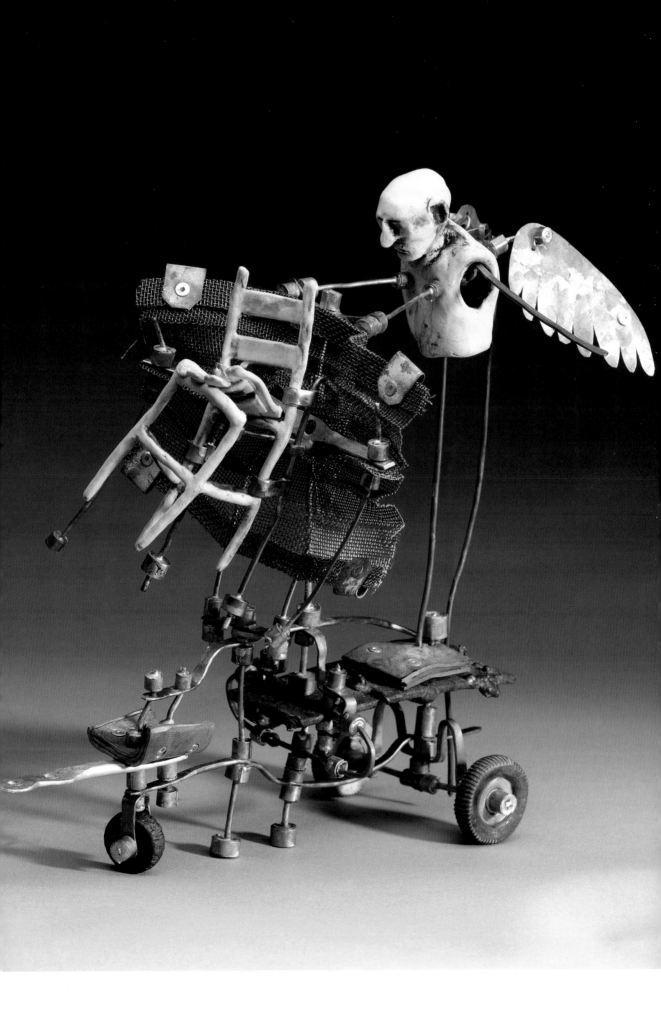

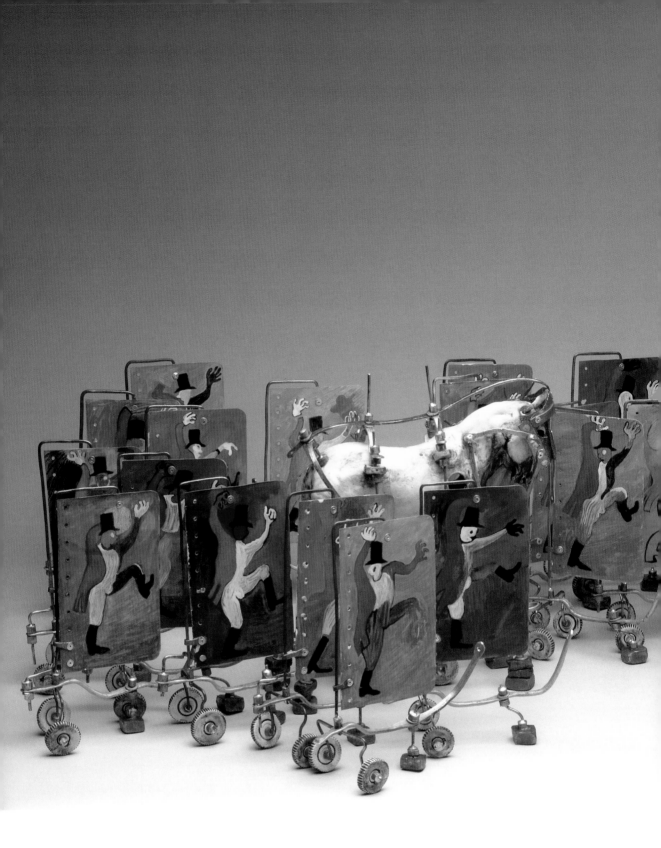

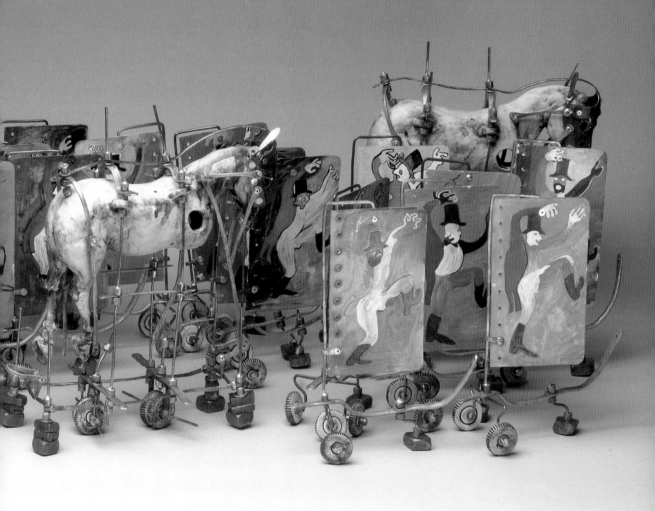

*you go to war
with the army you have.*
2011
ceramic, mixed metals, paint
Components for installation
include 50 paintings on trailers
and 4 ceramic horses on wheels.

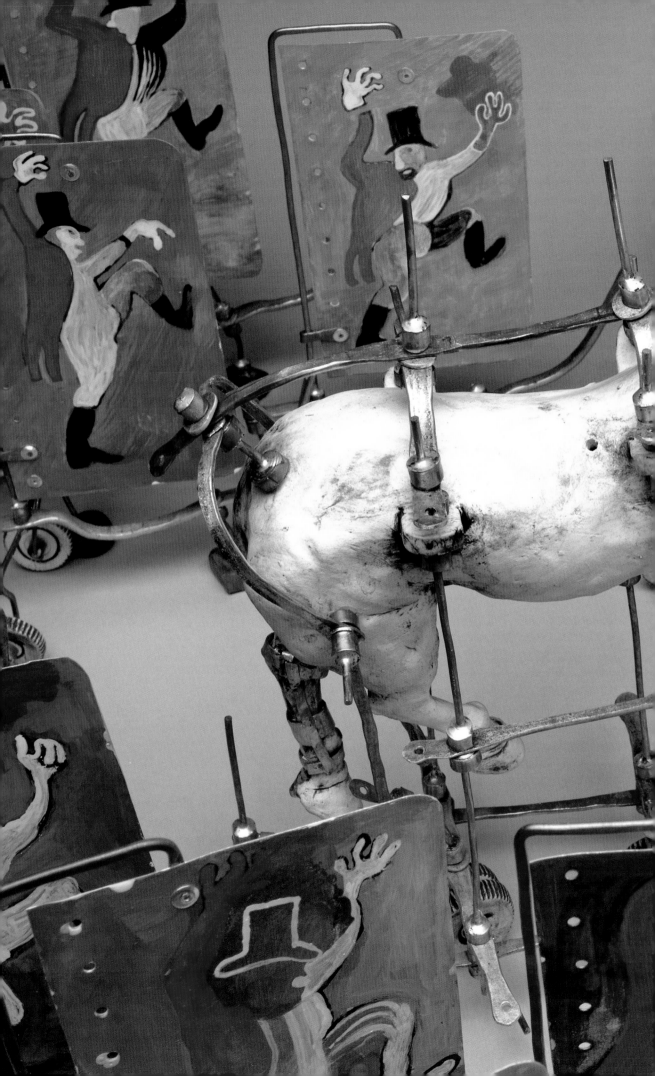

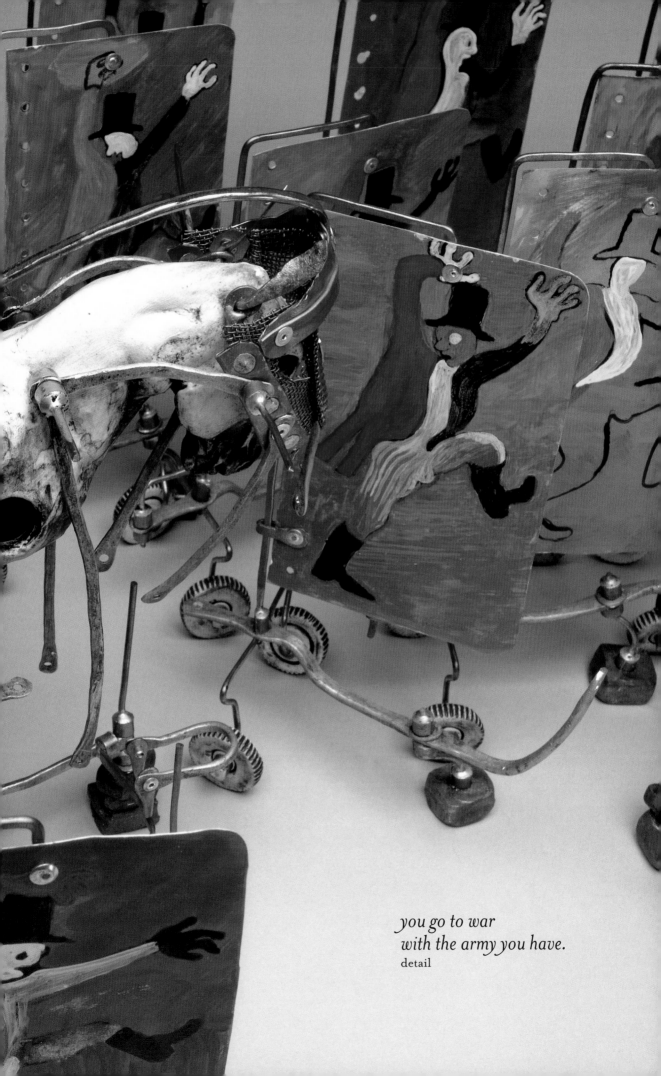

*you go to war
with the army you have.*
detail

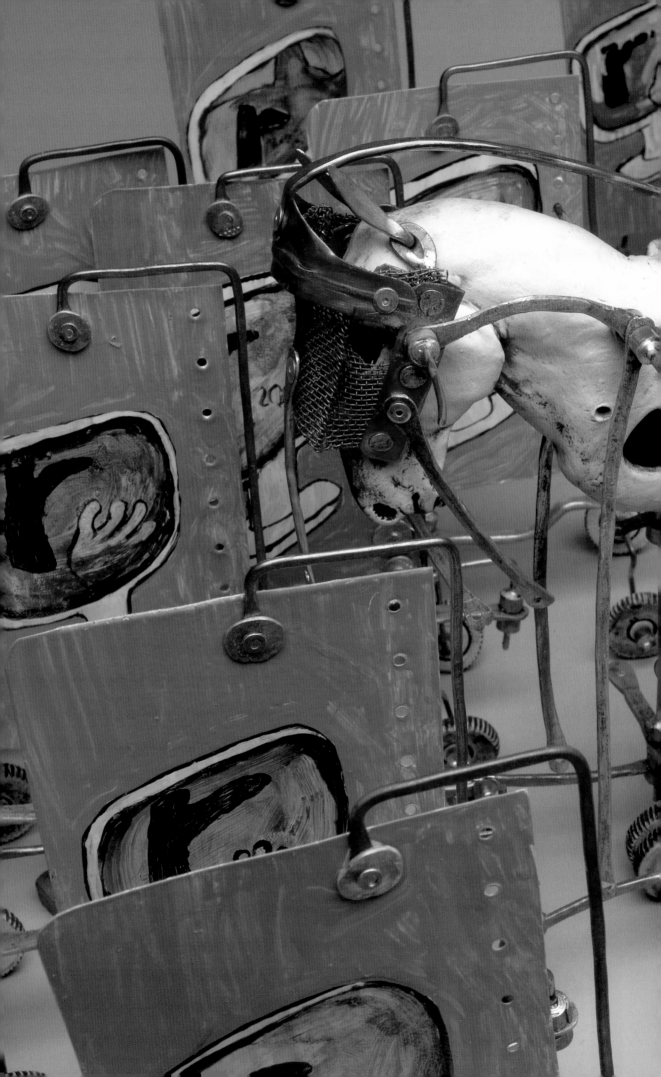

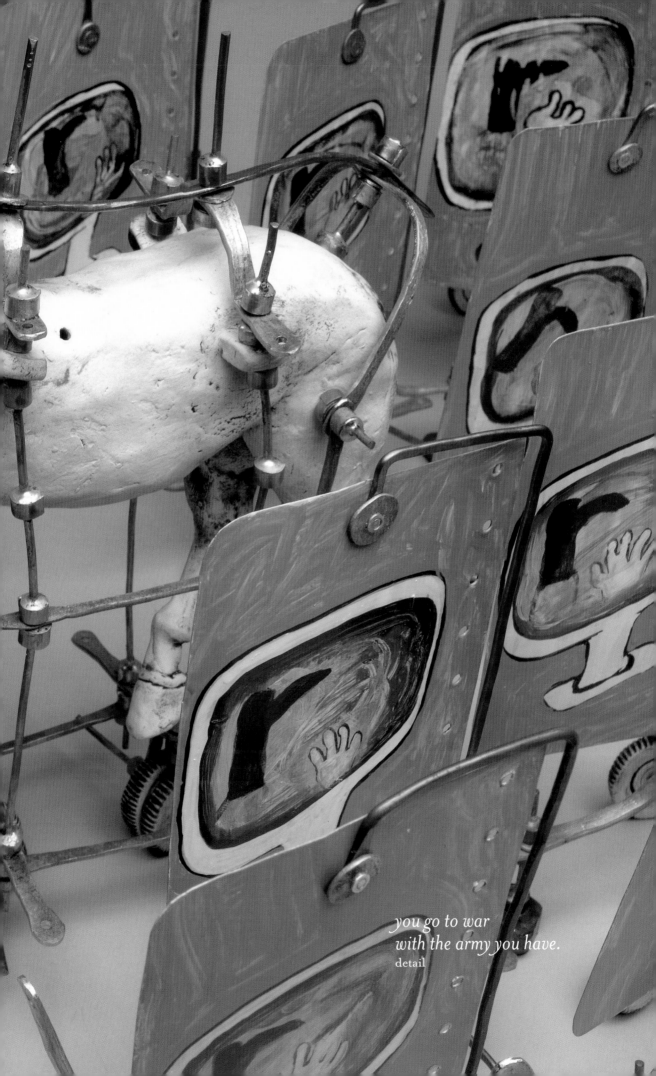

*you go to war
with the army you have.*
detail

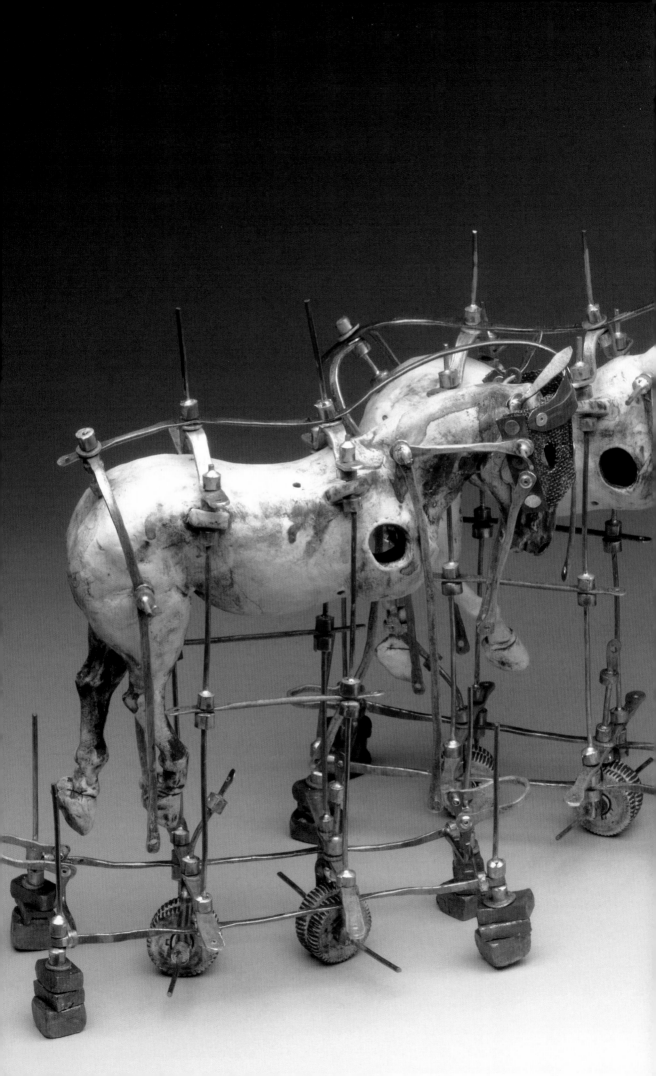

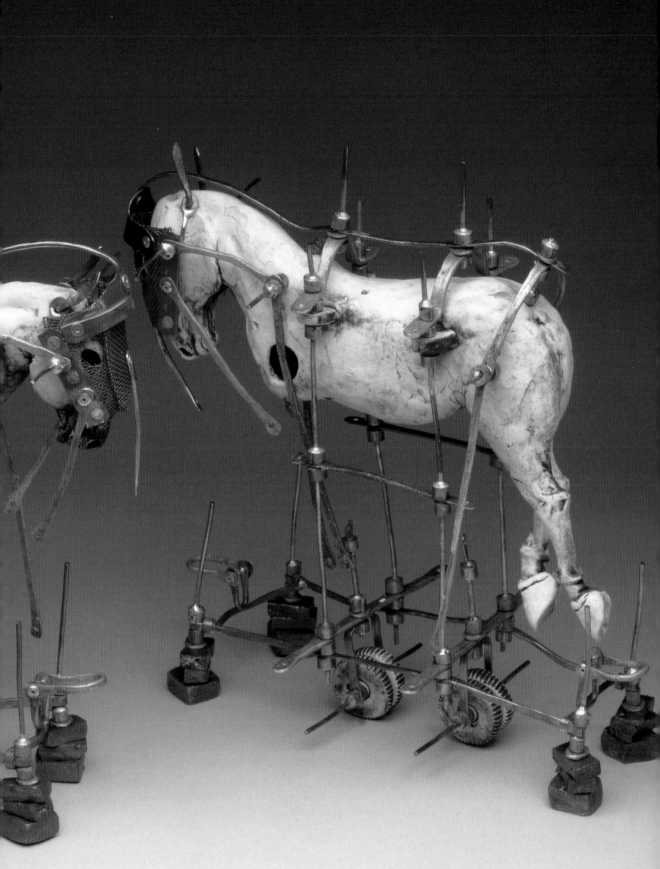

*you go to war
with the army you have.*
detail

Aggie Zed *Interview*

Michael W. Haga: How does this exhibition differ from ones that you've had in commercial galleries, such as Nina Liu and Friends, or nonprofit galleries, such as your 2009 exhibition at Virginia Tech's Perspective Gallery?*

Aggie Zed: The main difference is that, with a commercial gallery, you're always thinking, to some extent, of the generosity of the gallery owner. You don't want to embarrass or handicap the owner by producing something strange. Of course, the issue of the work's viability for sales is important in a commercial context.

The neat thing is that those concerns go out of the picture for institutional exhibitions. The Halsey's shows are strong, and the gallery has a record of presenting socially conscious exhibitions. It's neat to be able to work in a space with such a reputation.

Early on, Mark (Sloan, director of the Halsey Institute of Contemporary Art) said that he hoped I would surprise both him and myself with the work I produced for the exhibition. I took that as permission to do what I thought one should do in such a situation. I wanted to spread out and see what new images would come in the work. It's not that I worry about things being pretty and palatable (that's not a concern to me), but this exhibition gives me an opportunity to do work that has more of an edge. I can be freer than I would be in a commercial gallery—excluding Nina's gallery, of course!

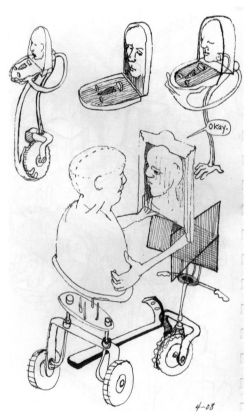

MH: Over the years, many new developments I've seen in your drawings and sculpture appear to have arisen in your sketchbooks. Tell me about the role your sketchbooks have in your creative process.

AZ: The sketchbook is a habit. After years of keeping dream journals and finally figuring out that I would not be a writer, I decided I wanted to use the mornings to key-in on the weirdness and otherworldliness of dreams, to introduce those elements into my working life.

I also had tons of doodles on scraps of paper and envelopes around the house, but I couldn't bring myself to toss them. With the sketchbook, I can have a place to gather images and their energy, and that's worked well for me. Drawing and writing in the sketchbook is what I know to do every day. It's a bad day if I can't put something into the sketchbook.

The basic rule is to look at the blank page, and start drawing without a plan. Usually, I see a strand of what I was working on the day before become a taking-off point from which things develop. For instance, if I was working on a scrap float the previous night (they can take three days or more to complete), I can use the sketchbook to solve mechanical problems or to investigate the scheme of the float's workings. Sometimes, I draw to remember correlations in the work or to have a record of the object on hand should it go into someone's collection.

The sketchbook is a place to consider or work out the next moves in whatever I'm working on at a given time. It's also a place where otherworld items appear first before going into large drawings. The sketchbook drawings serve as a takeoff point for larger works. I don't always use sketchbook drawings as the source or inspiration for working on the drawing wall, but doing that generally yields successful results.

Another feature of the sketchbooks is somewhat like the exquisite corpse writing exercise.

For years, phrases have been part of my drawings. As I work on the drawings, there's always a background of verbal interchanges going on in my mind. The comments may be tied to the images in the drawing, or the players in the drawings can be commenting about what is in the drawing or my work in the drawing. Sometimes, I go to the back of the sketchbook and write these comments there rather than put them in other drawings. Looking at the comments yields links to the images in the front of the book. It can be a bit random, but some days there may be multiple entries in that part of the sketchbook.

One of my reasons for including these phrases in the sketchbooks is that, once I put words on a drawing, it seems that the inscription directs the image. The words give me and the viewer a way of seeing and interpreting the drawing that is not open-ended. (Sometimes, I decide that a particular phrase will not restrict a drawing, but will simply give a hint of an intention to the viewer.)

After I started putting the phrases in the back of the sketchbook, I sometimes read what is there, just for the hell of it, and find myself laughing at the weird connections that appear. I think, "Where in the world did that come from?," but usually there is enough logic for there to be a structure in the words, even if I can't tie the words to a drawing.

Anyway, it's something I like.

MH: Your earlier drawings tend to include dark tones of black, brown, and gray with little color. Why is that?

AZ: I've been thinking about that. I love the dark ones and sometimes want to get back to where they originated. The most honest answer about their origins is that I had a limited palette of materials early on, once I graduated from college. For years, I was using India ink, charcoal, neutral ochres, and related colors and materials.

After school and in the early years, when I began to think of myself as someone who would make drawings, these were the materials I was working with. I tried a period of working with oils and a full palette of color, but I was disappointed with the results. I started to like drawings better than paintings, because they weren't thick and didn't get away from me.

For the most part, in the palette I was using I was limiting myself to a reduced range. Perhaps that was tied to a lack of knowing just what to do with a full palette. Color is a heck of a huge world!

Over the years, I've allowed myself more and more color. Sometimes, I've just picked a specific color when I've needed it for a particular drawing. I've developed a palette of trusted colors— ones that I know will work when I need them. I've become more confident, but color still can be a minefield!

MH: The drawings demonstrate how well you exploit (even encourage) random drips and runs. When did you begin to include them in the work, and how have you translated that kind of effect into your work with metal and recycled materials?

AZ: First, I think that was when I was at the University of South Carolina, in the seventies. Most of the work we were doing then was large, abstract paintings. It was almost a requirement or an expectation that one wouldn't work in a representational mode. I was making abstract paintings, and I thought I'd be a painter after I graduated.

By working in that way, I definitely learned to be loose in the work and to enjoy letting random things happen. With that background, I learned to keep the surface alive. I didn't want the paintings to be tight; I wanted to keep energy in the work. I always have worked standing up. The energy seems to come through the entire body. The feel of the work may be more athletic because of that.

The drips are something that has grown out of the background I developed in school. It's hard to explain why I love them so much. They look random, as if the thing on which I am working has its own life and breath. The drips are their own animal, almost as if the painting has another kind of breathing apparatus.

Rather than the image having a traditional foreground/background dynamic, the drips and marks that happen confuse and twist and create ambiguity and imperfections. In making recent drawings, I've found myself writing more phrases at the bottom of the images. There often is a skein or veil of drips in the image, and I have brushes that let me write or draw

with the ink (with some skill, but clumsiness often is a requirement!). I can manipulate a drip to look as if it happened after I wrote, thus changing the history of the image.

As for working with metals and other recycled materials, the way the spirit of dripping or randomness shows in the material is what intrigues me. I'm always looking for oxidized metal or other materials in the scale of what I'm doing. With the choice of a new, shiny piece of copper or something with a patina and marks on its surface, I'll take the messed-up piece any day. The trouble is that if those pieces are too cool, I have trouble committing to using them—I keep saving them for a better project!

The pieces of metal have a history that's the equivalent of the drips, and I try to use them in that way. Increasingly, I'm using enamels on metal for the scrap floats. I use

repeated coats and layers, and sometimes paint something such as a 4 x 6 painting on metal, and then bend and pound it to create a crease, and then flatten it again before adding it to the float. Of course, I have to plan ahead when using such materials.

MH: How did growing up on a Sullivan's Island that was not as developed as the one we know today influence your development as an artist?

AZ: That's almost unanswerable, but there are two things I am sure about. First, it's an island, so one looks at the horizon on the Atlantic, and that space, all of that sky, sets up a longing or questioning. There's a sense of something out there that you want to see. During and after college, I always said that I never would be able to be an artist there, because, with the sky being so perfect in itself, why would I need to make something? Beyond that, you just have to look at the green of the marshes and how it changes constantly. It seemed foolish to try to make things in that place.

The second thing is that I grew up on the end of the island, with gun emplacements and old foundations of forts all around us. That part of the island was basically empty. For about a quarter of a mile, there were unbuilt lots. We used to climb over the mounds and feed a neighbor's horses. As a kid, I never really understood the emplacements' purpose, but with their metal fittings and places for chains and hoists before me, my imagination ran wild. They were neat, raw places that invited all kinds of imagination.

Even when I was small, I always could depict things in drawings and interpret them spatially. For me, with that inborn ability to think spatially, the emplacements were like stages on which I wanted to make something happen. When I started making the scrap floats, I realized that their elements echoed the forms of the emplacements, and that I was building characters to interact with and on them.

MH: What artists' work has had an influence on you?

AZ: The list is way too long! Almost any art I look at has influenced me in some way. It's tough not to borrow or refer to art if something in it holds an attraction for you. If you're involved in art and the art world, how can you avoid influences from what you see? Even so, two artists I've loved from the get-go are Goya and Giacometti.

I admire Goya because he was a hell of a painter. His skill was incredible, but the subject matter . . . the *Caprichos* and *The Third of May, 1808*, is so incredible, and the horses' eyes are amazing in *The Charge of the Mamelukes*.

I'm also intrigued that Goya was a court painter who seemed to want to bite the hand that fed him. I really like the dark, satiric part of him that he expressed in his work, while he also made official images. I like the fierce part of him that commented on events and social injustice.

With [Alberto] Giacometti, I love the chariot pieces. You just get it when you look at the work. They're pieces that I've felt I've understood and from which I've learned. As the arc of his career continued, the pieces became smaller (thinner), and that's the opposite of what you'd anticipate, based on the careers of other artists. I always thought that was cool, perhaps because I've felt that I've had to defend the scale of my work.

I consciously tried to avoid making references to and taking influences from certain artists when I was fresh out of college. When I was younger, I was concerned about finding my way around the work of other artists, but that's not an issue for me now. For instance, I've heard people describe my sculptures of horses as knockoffs of Deborah Butterfield's work. I took those comments as an honor, but I think our approaches are very different. She does a wonderful job focusing on the horse. I know how I came to use horses in my work. It's a subject I claimed naturally, and I use the animals as a foil within the world of people.

MH: Your hybrid figures' forms tend to make me think of stories of Circe, Paleolithic art, and other references from mythology and art history. Are any of these things reference points for you?

AZ: The Paleolithic art is. Just look at the cave paintings at Lascaux or Altamira. How can anyone not be in awe of the natural grace of those images? Can any modern person even get to that kind of expression with materials like the ones that they used? They had to *be* the animals that they were painting; at least, it seems so to me.

I'm not really well-versed in Greek mythology, but the other day I was in the studio and had the television tuned to the History Channel. There was a program playing about Zeus, Hades, and Poseidon, and I remember thinking, "This is what Michael is always talking about!" The truth is, it wasn't an avenue I followed intentionally, but it could be accidental or subconscious.

MH: What process do you follow as you create your ceramic figures?

AZ: It's varied. To get to the quick of it, I began by producing chess sets. My idea was that sales of the sets would allow me to be able to afford to paint. When I graduated, I didn't want to fall into painting shrimp boats and magnolias in order to survive, and I didn't think there would be (and I didn't necessarily want to have) a market for my paintings.

The idea was that since I'd produce and sell chess sets to make a living, I had to learn what I had not learned at USC. One of my professors told me that serious artists don't draw horses. Of course, he could've sent me to see work by Degas or any number of other great artists! That caused me to make a chess set (in my room, and then fire it secretly!), because I could make four of the figures, the knights, as horses.

When I got out of school and was living in Richmond, I decided I'd try to produce a set like the one I had made at USC. I bought some clay and a kiln and learned how to work with glazes, and that's what got me started. I was modeling the chess pieces, and all of my work in clay goes back to that start.

After a while, I became more facile at working with the clay. Basically, I was doodling in three dimensions when I came upon building the first hybrid figures. It started naturally as I worked with the idea of the knight for the chess sets. That form got me started knowing I could put an animal's head on a human body and make it work. The first hybrid figure I made was Horse Man. More and more forms have developed over the years, but I've focused on images that have struck me as being strong, poignant, and powerful. Pigs are tough, because it's hard to give shoulders to them!

MH: What do you find to be most challenging as you work?

AZ: Materials! Trying to get materials to cooperate is an issue across the board in anything I do. For example, when I'm working on drawings, I'm working on paper that is not meant to support water-based media. I'm also spraying pastels with water, so I'm always getting into situations in which I'm struggling to avoid muddiness, wearing holes in the paper, and things like that.

When I'm working with metal for the scrap floats, the problem I face is juggling the ceramic components so that they look as if they fit with or go with the metal elements. I

have to make them make sense together. I also have to be aware of the fragility of the ceramics and address that logically in designing and building the floats. I have to put in and then remove some of the ceramic elements as I'm working, hold parts in place in order to make soldered parts secure, and avoid smashing figures.

Materials always are the biggest challenge. Anyone who says differently is not telling the truth!

MH: You wrote a letter of support when Nina Liu was nominated for an Elizabeth O'Neill Verner Award.** In that letter, you wrote that Nina "has helped my work find several other galleries across the country," and that she "has had an unerring sense of what would be good for my career and creativity without ever once telling me what I ought to do." Can you elaborate on those comments?*

AZ: Nina is just wonderful. She's always been so nurturing and supportive. She's incredible, and she sets a high standard both as a gallery owner and as a person an artist can collaborate with in creating work.

Nina has given me several nice shows over the years, but there's never been even a hint of commercial pressure for her convenience or benefit in our dealings. She often would report wonderful things to me that people said about my work and leave it at that. Not once did she try to get more work to fit popular demand. "Whatever you make will be wonderful" is Nina's standard statement, and she never has rejected anything that I've sent to her. She always has a great sense of humor, is easy to laugh with, and puts up with my dark sense of humor. That's a good quality in Nina. Everything is fine with her!

Nina has been vastly important to me as an artist. The permissive approach she's taken to our relationship as gallery owner and artist has allowed me both to make a living and to do things that were new and experimental. To me, this is something that is really important.

One thing I've managed to accomplish in my life is that I've been able to make a living from my work while keeping it alive. It seems that, so often, artists or creative people figure out how to make a living, but then find that making money interferes with their creative side. So many people have known me only through the ceramic figures (and they were an outgrowth of my idea of selling chess sets to support myself) and the wire/clay horses. Consequently, many people think that the figures and the horses comprise the main body of my work. Until now, with the exhibition at the Halsey, Nina has given me just about the only place where I've felt completely free and not pulled my punches. With the Halsey show, I seem to be moving into a new phase in my work.

Understand that I'm not trying to cast aspersions on my work in clay! I'm just lucky I'm able to make things I enjoy and that keep their integrity, while still making the more un-usual things that Nina has shown in her gallery. It's a rare thing to balance making a living and making art. Nina has helped me do that, and I value her support, guidance, and friendship.

MH: What has been the greatest artistic challenge for you as you've prepared for this exhibition?

AZ: The biggest challenge has been to focus. The show's given me an opportunity to work wide open. Mark never gave me a sense that I could do something wrong, and that was great. As I said before, he told me he hoped that what I produced for the show would surprise both of us. The incredible location that is available for the show is a great space for me, given the intimate scale of my work. It let me think and let the work open up. For instance, I was able to double the size of the drawings overnight.

The increase in the size of the drawings was ready to happen, but I was shocked at how quickly it happened. I've gone from working on sheets of paper that are about 20 x 26 to sheets that are about 26 x 40. They just jumped right up to that size.

The first of the large drawings originated from sketchbook images, and as I was mak-ing them I realized I had no problem with the new scale. Perhaps I shouldn't judge my own work, but I feel power in them. The shift of scale was great.

MH: Talk about the installations that you've created for the exhibition.

AZ: Oh, man! The one I call *you go to war with the army you have* arose from work I was doing based on *Noble, a Hunter Well Known in Kent*, a painting from 1810 in the Virginia Museum's Mellon Collection. I took the character of the rider, who is very upper class, and worked with him over time. The figure has been in the sketchbook for so long that I decided he would be in the installation. I cut pieces of metal into "pages" and painted the same figure with enamel paints fifty times. They look like dancing fools, and each small painting is on a little trailer, as if it's rolling along somewhere. On the other side of each image of a man is a painting of a computer monitor. Among the images of the men are ceramic horses on wheels and an apparatus with scaffolding that supports them. The horses are masked and have no forelegs. They are hauntingly beautiful.

I got the title for the installation from a comment that Donald Rumsfeld made during a press conference. He was talking about the equipment that was available as we were going to war. I have a television in the studio. At one point, I was a news junkie, and I had CNN on all of the time. Rumsfeld was a powerful character. I think that *you go to war with the army you have* raises a number of questions.

Another one is *Elephants Observed*. It includes one hundred of the little elephants, and among the herd are four ceramic staircases on wheels. When I began making the herd, I just wanted to see what one hundred of the elephants would look like. Then, I thought of the herds in Africa, and how one often sees them from an aerial perspective, in images that include the shadow of the plane that carries the photographer. I wanted to include with the elephants something that would give a sense of them being under observation. I thought the staircases would look cool, and decided they would be the observation element in the installation.

The staircases are a "man-made" object that would tower over the elephants if the proportions were lifesize. I'm really pleased with it. I've assembled it in the studio with the fine sand from Sullivan's Island. It looks really good, and I imagine it'll have much the same impact in the gallery.

MH: *Other than changes in scale, has preparing the drawings, sculptures, and installations for the exhibition led you in a new direction in your work?*

AZ: Well, scale is the obvious answer. It's hard to say, because the way the work evolves makes it difficult to see starting and stopping points in it. The work I'm producing for this show may be freer than what I might've created for a commercial venue. I could see myself doing more multiples as installations in the future.

Every day is so new to me that the hardest thing is not to get distracted by some neat thing rather than do what I need to do. Some days, I'll sit at the worktable and find I've spent the day with something I had no intention of building. The most important thing for me is for it to be free, to feel that I'm producing something not because it has to be done but because I'm discovering something new.

MH: *What are you thinking of as you consider the work that you'll create in the near future?*

AZ: When it's working well, it just flows. There are times when I'm involved in busy work, such as pounding out metal elements, but the really cool stuff is in discovery. Even in the installations, the repeated elements are different. My favorite thing is to be making, drawing, or building something and have the thing grab me and not want to let go.

*Nina Liu and Friends is a contemporary art gallery that has operated in Charleston for more than twenty-five years.
**The Elizabeth O'Neill Verner Governor's Awards for the Arts, the highest honor the state presents in the arts, date to 1972. The awards recognize outstanding achievement and contributions to the arts in South Carolina. In 1980, the awards took on the designation of the official "Governor's Awards for the Arts" in South Carolina. According to the South Carolina Arts Commission (SCAC), "These awards honor South Carolina arts organizations, patrons, artists, members of the business community, and government entities who maximize their roles as innovators, supporters and advocates of the arts."

This interview was conducted on September 7 and 8, 2011, by Michael W. Haga, associate dean at the College of Charleston School of the Arts. Haga has written exhibition reviews for such publications as The New Art Examiner, Art Papers, Carolina Arts, *and* Charleston City Paper. *He has juried numerous exhibitions in the southeastern United States and served as a grant panelist for such agencies as the South Carolina Arts Commission and the Oregon Arts Commission.*

Aggie Zed

Born Charleston, South Carolina, 1952
Richmond, Virginia, 1976–98
Gordonsville, Virginia, 1998–

Education
University of South Carolina, BFA Painting and Sculpture (cum laude), 1974

Awards and Fellowships

1986	National Endowment for the Arts Professional Fellowship, Sculpture.
1982	Virginia Commission for the Arts Professional Fellowship, Sculpture.

Selected One-Person Shows

2009	*Sculpture and Painting*, Perspective Gallery at Virginia Tech, Blacksburg, Virginia.
	Sculpture and Paintings, with Bill Moretz, Rivermont Studios, Lynchburg, Virginia.
2007	*It's About Time, Sculpture and Painting*, with John Morgan, Avenue Arts, Lynchburg, Virginia.
2006	*Aggie Zed—Recent Work*, B. Deemer Gallery, Louisville, Kentucky.
2004	*Things Do Bite Back, Sculpture and Painting*, with John Morgan, Nina Liu and Friends Gallery, Charleston, South Carolina.
	Know Show, Paintings, with John Morgan, Astra Design, Richmond, Virginia.
	Paintings, B. Deemer Gallery, Louisville, Kentucky.
2003	*Sculpture and Paintings*, Nina Liu and Friends Gallery, Charleston, South Carolina.
2001	*Scrap Floats and Jetsam, Sculpture and Paintings*, Astra Design, Richmond, Virginia.
2000	*Paintings*, Sweetbriar College, Sweetbriar, Virginia.
	Sculpture and Paintings, Nina Liu and Friends Gallery, Charleston, South Carolina.
1999	*Paintings*, The Art Works Gallery, Norfolk, Virginia.
1998	*Sculpture and Paintings*, Nina Liu and Friends Gallery, Charleston, South Carolina.
	Paintings, Astra Design, Richmond, Virginia.
1997	*Paintings*, B. Deemer Gallery, Louisville, Kentucky.
	Sculpture and Paintings, Nina Liu and Friends Gallery, Charleston, South Carolina.
1996	*Its Own Little Animal, Paintings*, Astra Design, Richmond, Virginia.
1995	*Paintings*, Nina Liu and Friends Gallery, Charleston, South Carolina.
1993	*Sculpture*, Nina Liu and Friends Gallery, Charleston, South Carolina.
1986	*Mortal Oxide*, Two-person Show, 1708 East Main Gallery, Richmond, Virginia.
1984	*In the White Room*, Anderson Gallery, Virginia Commonwealth University, Richmond, Virginia.

Selected Group Shows

2007	*In the Spirit*, Nina Liu and Friends Gallery, Charleston, South Carolina.
	Horse Crazy, A Horse of a Different Color, Jackson, Wyoming.
	Uncorrupted Horses, Riverfront Studios, Schuylerville, New York.
	Go Figure, Nina Liu and Friends Gallery, Charleston, South Carolina.
2006	*Amazing Clay*, Staunton Augusta Art Center, Staunton, Virginia.
	Five Virginia Artists, Nina Liu and Friends Gallery, Charleston, South Carolina.
	Alumni Exhibition, McMaster Gallery, University of South Carolina, Columbia, South Carolina.
2005	*All Fired Up*, Somerhill Gallery, Chapel Hill, North Carolina.
2004	*Myrtle Beach Collects*, Franklin G. Burroughs-Simeon B. Chapin Art Museum, Myrtle Beach, South Carolina.
	South Carolina Birds, Sumter Gallery of Art, Sumter, South Carolina.
1997	*Figure 8*, Spruill Center Gallery, Atlanta, Georgia.
1995	*Making a Mark*, Bedford Gallery, Longwood College, Farmville, Virginia.
1994	*Pandora's Box*, Hand Workshop, Richmond, Virginia.
1993	*The Artist As Activist*, Sawtooth Center for the Visual Arts, Winston-Salem, North Carolina.
1991	*Sculpture*, 1708 East Main Gallery, Richmond, Virginia.
	The Art of the Mask, International Gallery, San Diego, California.
1985	*Southern Comfort/Discomfort*, The Mint Museum, Charlotte, North Carolina.
1983	*Sculpture*, Contemporary Art Gallery, Virginia Museum of Fine Arts, Richmond, Virginia.

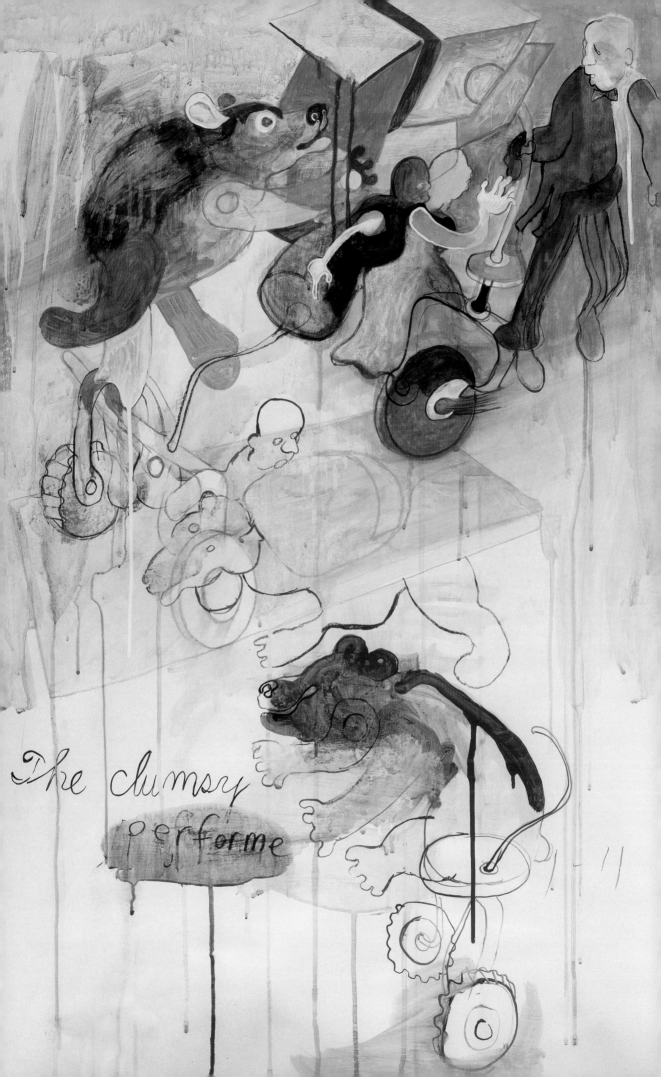

The clumsy performe

Acknowledgments

The Halsey Institute of Contemporary Art wishes to thank its many members and patrons for their support of its programs. We gratefully acknowledge the Gaylord and Dorothy Donnelley Foundation, the Andy Warhol Foundation for the Visual Arts, the Coastal Community Foundation, the Yaschik Foundation, and the Joanna Foundation for their ongoing support. For this exhibition and publication, we particularly wish to thank Artizom Art and Frame Gallery, photographer Bill Moretz, graphic designer Gil Shuler, JMO Woodworks, Rene Nedelkoff at Four Colour Print Group, videographer John David Reynolds, composer-musician Bill Carson, web designer Buff Ross of Alloneword Design, Michael W. Haga, and Dean Valerie Morris of the School of the Arts at the College of Charleston. We also wish to thank the many friends and admirers of Aggie Zed who helped make this publication a reality.

Special recognition:
Nina Liu

Project sponsors:

Ann W. Burrus
Jim Calk & Betsy Havens
Mary Case & Will Lowe
Patricia & Scott Corbett
Corduroy Charitable Trust
Leslie C. Cradock
Pernille Ægidius Dake
B. Deemer Gallery
Leilani Demuth
Terry Fox
Michael W. Haga
Amelia T. Handegan, Inc.
Kathleen Hoppe
Hanson Howard Gallery
Paul W. Holmes
Sosie Hublitz
Jack Blanton Collection
Blanding U. Jones, MD
Jo Lee & Chuck Kenney
Marty & Julie Klaper
Aria Knee

Jeff Kopish/limeblue
Lynn Letson
Richard & Yvonne McCracken
Arthur & Gloria McDonald
Pal & Andrea Maleter
Charlotte & John Morgan
Kate Nevin
David & Robben Richards
Mimi Sadler & Camden Whitehead
Leslie Scanlan
Arthur & Julia Smith
Bob & Diane Sneed
Brian & Sherry Stone
Connie Stone
David Stone
Thompson Parker Barnwell Memorial Fund
Billy Vandiver
Sue Westmoreland
Rick & Brenda Wheeler
Zed, Tina & Ann-Marie White
Emily White

previous page
The clumsy performe
2011
pastel, ink, acrylic on paper
40" x 26"

at right
earful
2010
pastel, ink, acrylic on paper
40"x 26"

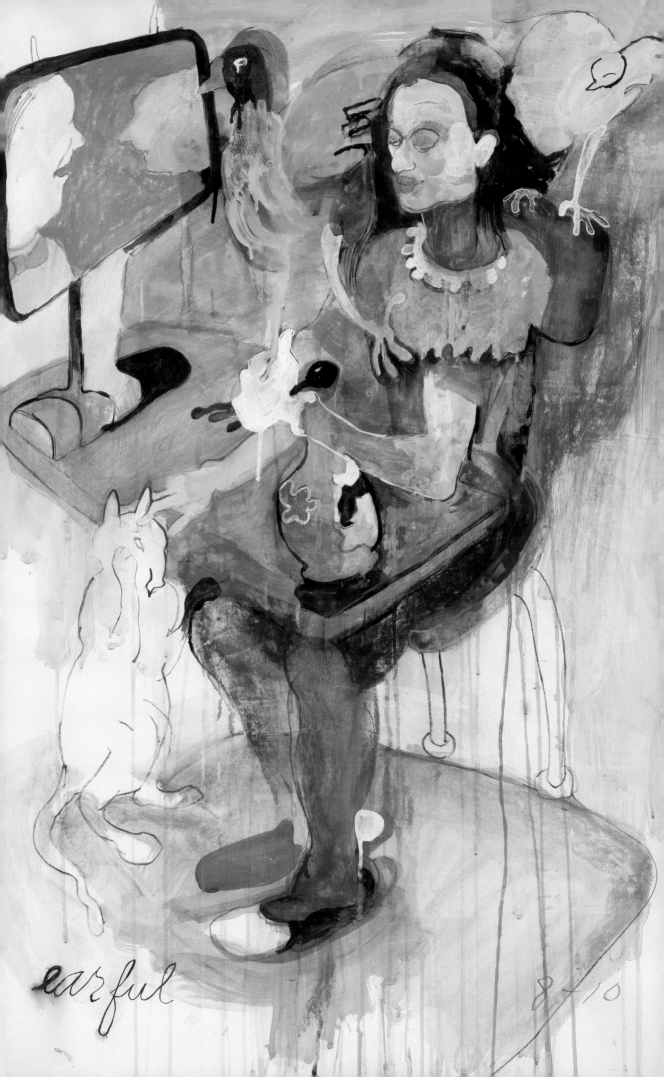

earful

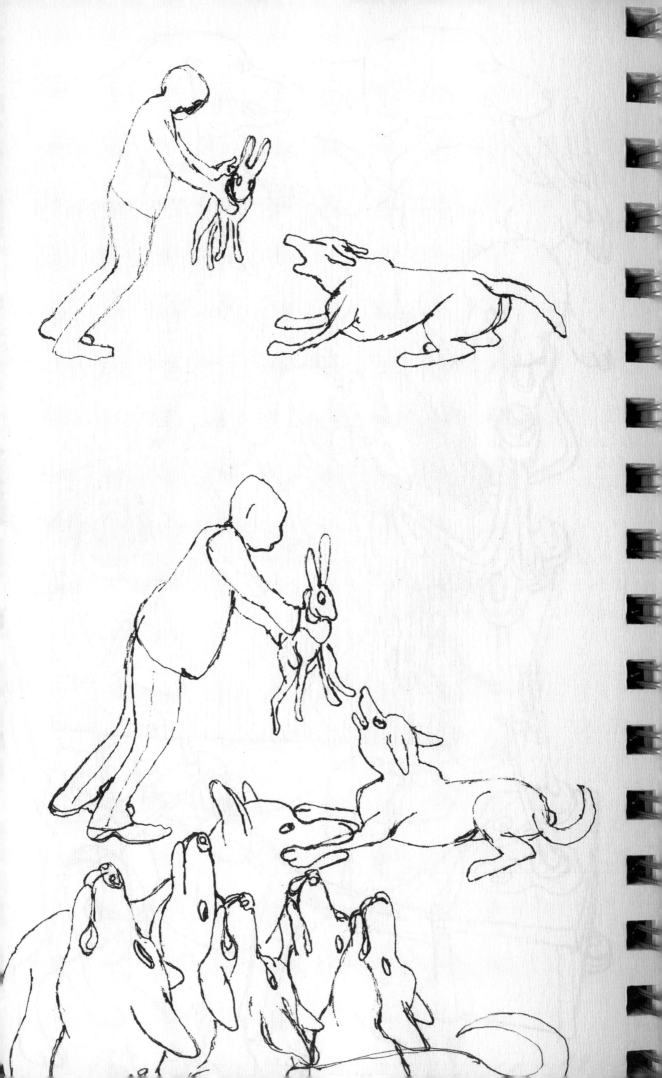

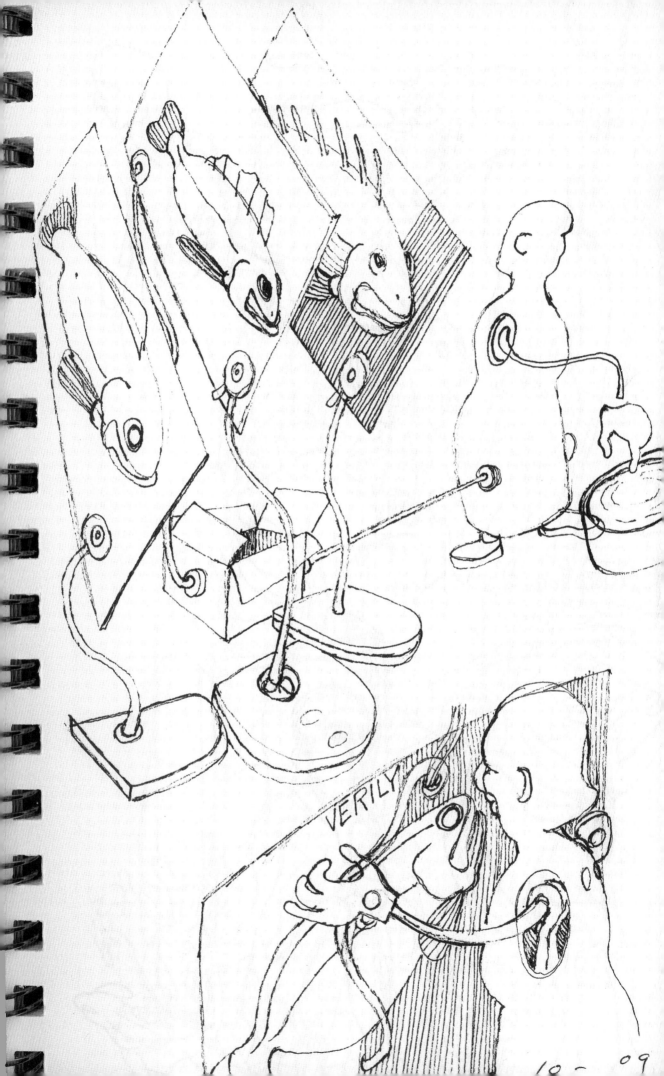

VERILY

10-'09

NON - FUNCTIONING HAHA

Not that kind of engineer

He's the one who gave her the oar locks.

Here would be a look for its face.

Bandage that before they get here.

And here was my hair.

Some of the first to fly through a wall

How much of this are you going to mop up?

Wild animals are not interested in you.

The Last Voyage of The Captain You

I spent all day trying to make that look like oil he was eating.

Give it a minute.

What part of this story would you want to hear?

Fictional sisters

Bobby, will you still float?

They need to have highly absorbent fur.
And know how to wring themselves out.

Wiffy's pancake clocks

Dope Star

Hungry wing

Say bye bye.

P.S.

Boil is a good word.